IMAGES
of America

CHARLOTTESVILLE

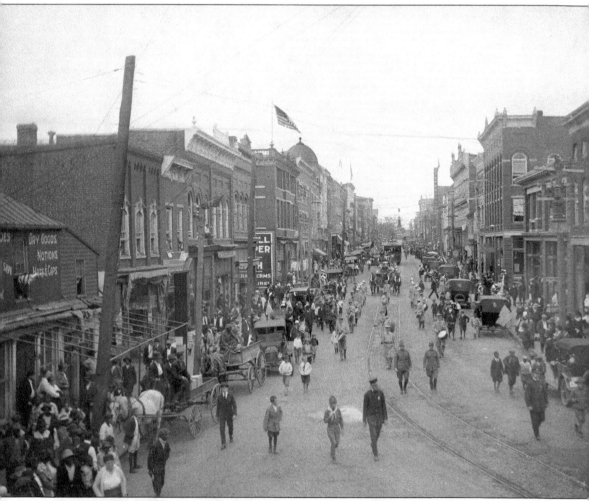

ON THE COVER: On September 24, 1917, a military parade honored the Monticello Guard, Company D, 1st VA, which had been established in Charlottesville in 1857. The *Daily Progress* reported that this parade was an impressive and inspiring send-off for the company, which immediately left for training at Camp McClellan, Alabama. The Veterans of the Confederacy, the Home Guards, and a local women's Red Cross unit also marched in the parade. The Monticello Guard went on to serve with distinction in France during World War I. (Courtesy of Holsinger Collection [MSS 9862], Special Collections, University of Virginia Library.)

IMAGES
of America

CHARLOTTESVILLE

Eryn S. Brennan and
Margaret Maliszewski

ARCADIA
PUBLISHING

Published by Arcadia Publishing
Charleston, South Carolina

Library of Congress Control Number: 2010939828

For all general information, please contact Arcadia Publishing:
Telephone 843-853-2070
Fax 843-853-0044
E-mail sales@arcadiapublishing.com
For customer service and orders:
Toll-Free 1-888-313-2665

Visit us on the Internet at www.arcadiapublishing.com

For Jay, Bill, Colleen, and Kendra

CONTENTS

ACKNOWLEDGMENTS

Local historian John Hammond Moore once said, "Telling local history is an awesome task." No truer words have been spoken. It is with great care that we searched through over 15,000 images from 30 different collections to choose the 223 for this project. These images represent our impressions and understanding of the ebb and flow of time in a place we have come to love over many years. Perhaps most striking in compiling this pictorial history is the understanding that history is as much about the study of change as it is about the study of the past. We offer these images as snapshots of those changes that have left the most indelible prints on the historical and contemporary landscape of Charlottesville.

This project would not have been possible without the generous assistance of numerous individuals who shared photographs, identified previously little-known collections, read drafts, and checked facts. In particular, we would like to thank Steven Meeks and Margaret O'Bryant at the Albemarle Charlottesville Historical Society for opening their collections and for their insightful comments on drafts of each chapter. In addition, Nancey Bridston Hocking, Emma Earnst, and Keri Matthews guided us through the labyrinth of archives at the Society. We are grateful to Heather Riser and Nicole Bouché, who assisted us in procuring images from the Albert and Shirley Small Special Collections Library at the University of Virginia. We would also like to thank Ed Roseberry, Jim Carpenter, Jack Looney, John Shepherd, and Brian Painter for sharing with us their impressive personal photographic collections. For their immeasurable assistance with this project, we extend much gratitude to Preston Coiner, Sara Lee Barnes, Richard Guy Wilson, Mike Fitz with the University of Virginia Alumni Association, Bob Short with Short Insurance Associates, Sandy DeKay at the Paramount Theater, Timothy Hulbert with the Charlottesville Regional Chamber of Commerce, Amy Kilroy with the Charlottesville Redevelopment Housing Authority, Jared Loewenstein, Margaret Hench Underwood, Jane Beckert, Christina Deane at University of Virginia Digital Services, McGregor McCance at the *Daily Progress*, Jim Boyd, Janet Hendrix, Kate Bailey, Virginia Gardner, Ann Adams, George C. Seward, Jeff Werner, and Jim Tolbert and Mary Joy Scala at the City of Charlottesville.

Pictured below are some of the photographers whose work made this book possible. From left to right, they are Rufus W. Holsinger, Jackson Davis, Ed Roseberry, Russell "Rip" Payne, and Jim Carpenter.

INTRODUCTION

Albemarle County was created from Goochland County in 1744, and as the population increased, land was split off from Albemarle to create Amherst and Buckingham Counties. This relegated Scottsville, Albemarle's original county seat, to a non-central location, and led the Virginia General Assembly to establish Charlottesville in 1762 as the new county seat. The site was chosen for its central location and its convenience; it was located on the Three Notch'd (or Three Chop't) Road, the main east-west route from Richmond to the Shenandoah Valley and the Blue Ridge Mountains, and one mile west of the Rivanna River water gap through the Southwest Mountains.

The new county seat was named in honor of Queen Sophia Charlotte, wife of King George III. A settlement did not exist at the site and a simple grid was used to lay out the new town. The square stood adjacent to Jefferson Street, named for Peter Jefferson, a surveyor and prominent citizen, and father of Thomas Jefferson.

Any visitor to Charlottesville will quickly learn that Thomas Jefferson is Charlottesville's favorite son and the area is truly "Jefferson's country." With his University of Virginia firmly established to the west and his house on the "Little Mountain" overlooking from the east, Jefferson's influence is inescapable in Charlottesville. Jefferson walked Charlottesville's streets, influenced the town's development, established its persistent architectural style, and here envisioned a way of life for a new nation.

Charlottesville mourned Jefferson's death in 1826, and his legacy established Charlottesville as a tourist destination beginning in the early 19th century. Today, historic preservation is a hallmark of the city and surrounding area, and millions of people visit each year. Jefferson's architectural legacy was recognized with the Thomas Jefferson Memorial Foundation's purchase of Monticello in 1923 and the subsequent formal opening of Jefferson's home to the public. It was further acclaimed by the 1987 designation of both Monticello and the Academical Village at the University of Virginia as World Heritage Sites. The city's historic architecture has been protected by the designation of eight historic districts and 74 individual properties as local landmarks. The built fabric of the city and the surrounding area have been honored with nearly 100 individual properties and historic districts listed in the Virginia Landmarks Register and the National Register of Historic Places. Clearly, the area remains rich in historic fabric held dear by Charlottesville's citizens, and today's city is an extremely diverse mix of old and new.

This book is divided into chapters that illustrate significant periods and trends in Charlottesville's development. The chapters begin with the first establishment of the town, through the earliest period of growth, to the establishment of Jefferson's university. They continue with the growth of commerce along Main Street and the expanding city boundaries, to the challenges of integration and economic downturns, and the resurgence of downtown as the focus of city life. The images in this book tell the story of Charlottesville and portray its citizens as they have lived amidst the fabric of a particularly historic American town.

There exists an abundance of photographs that illustrate Charlottesville's history. Those chosen for this book strive to balance the most iconic images with others that are perhaps unfamiliar to most viewers. Some photographs capture moments of celebration; others document difficult struggles. Some illustrate important historic events; others capture everyday occurrences. Some images have been grouped to highlight changes that have transformed the urban landscape. Others show how little some of the city's treasured places have changed. It is our hope that this collection will rekindle memories for longtime residents, surprise newcomers, enlighten visitors, and prompt continued discussion, reevaluation, and appreciation of our shared history.

One

THE FOUNDING OF A TOWN
CHARLOTTESVILLE IN THE
18TH AND 19TH CENTURIES

The 1762 General Assembly act that established Charlottesville required 50 acres to be laid out in streets and lots. Thomas Walker laid out the lots in a rectilinear grid just south of a two-acre courthouse square. A courthouse, jail, pillory, stocks, and whipping post were constructed in the square, which quickly became the center of civic and commercial life in the early town. This map shows original street names and additional lots annexed to the north in 1818. (Courtesy of Visual History Collection [RG-30/1/10.011], Special Collections, University of Virginia Library.)

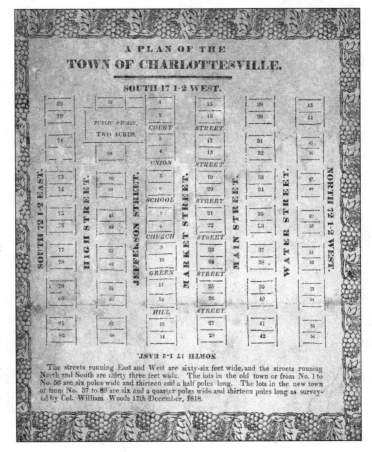

James Madison met Thomas Jefferson in 1776, and they developed a lifelong friendship. Madison served as a representative to the Virginia House of Delegates, a member of Governor Jefferson's advisory council, and as Virginia's delegate to the Philadelphia Constitutional Convention, where his service distinguished him as the Father of the Constitution. In 1809, he became the fourth president of the United States. His presidency spanned the War of 1812, during which he commanded troops in the field. Madison was rector of the University of Virginia upon Jefferson's death in 1826, and he died in 1836. (Courtesy of Prints File, Special Collections, University of Virginia Library.)

Approximately 4,000 British and German prisoners of war were taken at the 1777 Battle of Saratoga in New York. Faced with a long northeast winter and insufficient food, the Continental Congress decided to march the soldiers to Virginia. Col. John Harvie offered land on Ivy Creek, about four miles west of Charlottesville. Prisoners arrived in early 1779 at an unprepared camp.

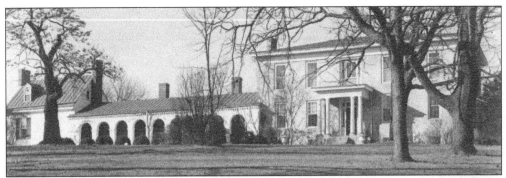

James Monroe fought in the Revolutionary War, crossing the Delaware with George Washington, and in 1817 became the fifth president of the United States. A lifelong friend of Thomas Jefferson, he purchased a farm west of Charlottesville in 1788. A portion of this first farm was sold in 1817 and eventually became part of the University of Virginia. Some of the 12 dorms constructed in 1848 adjacent to the farmhouse in the arcaded style of the ranges are visible in this photograph, as are the farmhouse and Monroe's office. Monroe moved to Highland, a large working farm adjacent to Monticello, in 1799, and died on July 4, 1831. (Courtesy of Albemarle Charlottesville Historical Society.)

Many constructed their own housing; some were housed in local homes. By spring, the camp looked like a small town. A Georgian-style residence called "The Barracks" was constructed on the site in 1819. Today's Barracks Road leads toward the site of the encampment. (Courtesy of Prints File, Special Collections, University of Virginia Library.)

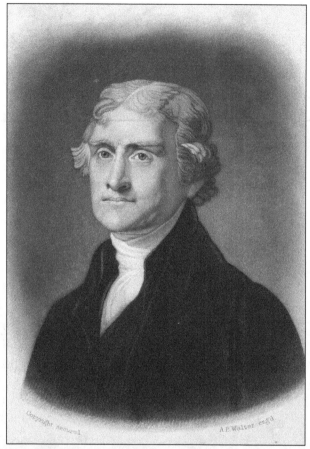

Thomas Jefferson was born in 1743 at Shadwell, Virginia. During his life, he distinguished himself as an accomplished farmer, architect, educator, author, lawyer, politician, legislator, diplomat, and as the third president of the United States. Jefferson retired to Monticello, his house on the "Little Mountain," following his presidency. Retirement from political office allowed him to focus more on his passion—the establishment of the University of Virginia, which opened in 1825. Jefferson died on July 4, 1826, the 50th anniversary of the signing of the Declaration of Independence—just hours before the death of his friend, John Adams, the second president of the United States. His epitaph cites the accomplishments he held most dear: author of the Declaration of Independence and the Virginia Statute for Religious Freedom, and father of the University of Virginia. (Courtesy of Prints File, Special Collections, University of Virginia Library.)

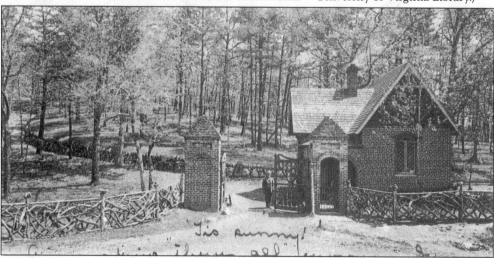

One means of access to Monticello was from the summit of Thoroughfare Gap, the location of today's Saunders Bridge. There is no evidence of a gatehouse here during Jefferson's residence, but this structure was built by the 1890s, during Jefferson Monroe Levy's ownership. For generations, members of the African American Coleman-Henderson family, employees of the Levy family, lived in and worked at the gatehouse. (Courtesy of Preston Coiner.)

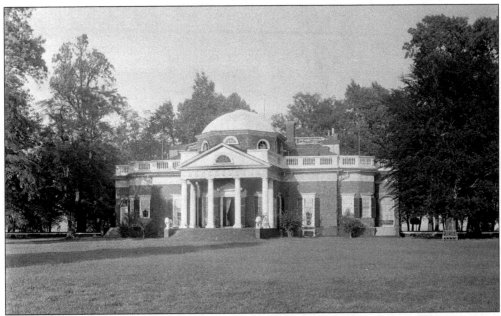

Jefferson began construction of his house around 1770. The initial design was a Palladian-inspired residence featuring a two-story central structure with porticoes at both levels. Returning from Europe in 1793 and strongly influenced by French architecture, Jefferson redesigned and rebuilt his home. He removed the second-story portico, establishing a lower, more horizontal form, and added an octagonal dome on a drum. The result, as shown here, is a monumental but simplified and unified appearance. Construction was mostly complete by 1809, but alterations continued throughout Jefferson's life. Monticello's basis in classical antiquity embodies Jefferson's ideal architectural style for the new nation. (Courtesy of Holsinger Collection [MSS 9862], Special Collections, University of Virginia Library.)

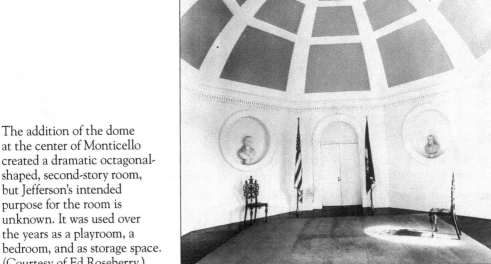

The addition of the dome at the center of Monticello created a dramatic octagonal-shaped, second-story room, but Jefferson's intended purpose for the room is unknown. It was used over the years as a playroom, a bedroom, and as storage space. (Courtesy of Ed Roseberry.)

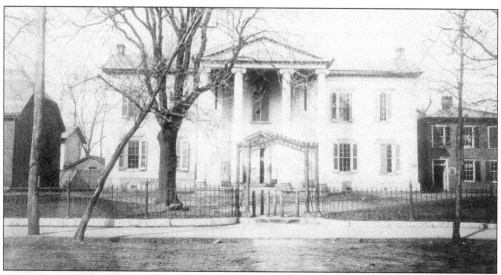

The original courthouse in Charlottesville's Court Square was a frame structure. Sources differ as to its date of construction, but most agree that it was built by 1763. It was replaced in 1803 by a two-story brick building, which Jefferson referred to as a "common temple." Prior to the construction of churches in town, it was used by various religious denominations on a rotating basis. The "temple" now forms the north (or rear) wing of today's courthouse. In 1860, an addition was constructed on the south side in the Gothic Revival style. A portico was added in 1870, as seen in this photograph. (Courtesy of Visual History Collection [RG-30/1/10.011], Special Collections, University of Virginia Library.)

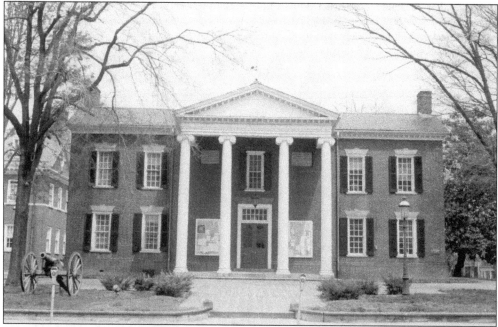

The courthouse was remodeled in 1938 in the popular Colonial Revival style with a red brick front. A new county clerk's office was constructed as a Public Works Administration project, just to the west (left) of the courthouse in a similar style. (Courtesy of the Albemarle Charlottesville Historical Society, Allaville Magruder Collection.)

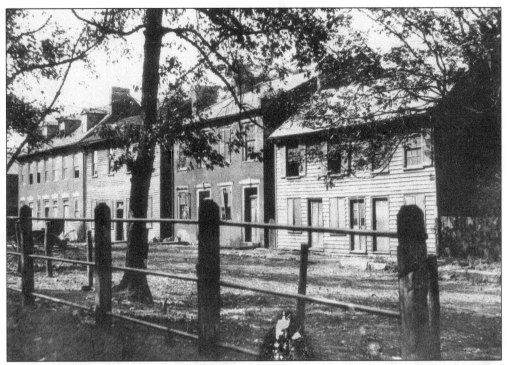

In the first half of the 19th century, the blocks closest to the courthouse developed as the town's commercial center. This photograph shows the McKee Block, which stood in what is today Jackson Park, running parallel to today's Fourth Street and facing Court Square. The fence surrounding Court Square is visible in the foreground. The block housed a printer, hatter, grocer, and other merchants, with residences above. Many of the McKee Block residents were African Americans. (Courtesy of the Albemarle Charlottesville Historical Society, Allaville Magruder Collection.)

Number 220 is one of a row of brick buildings on the east side of Court Square that replaced earlier wooden buildings beginning in the 1830s. This one was constructed around 1860 to house law offices. It replaced the house of Johnny Yeargan, a whiskey dealer. Near this site was a stone block used for auctioning slaves. The men in this picture are from the *Daily Progress*. (Courtesy of the Albemarle Charlottesville Historical Society.)

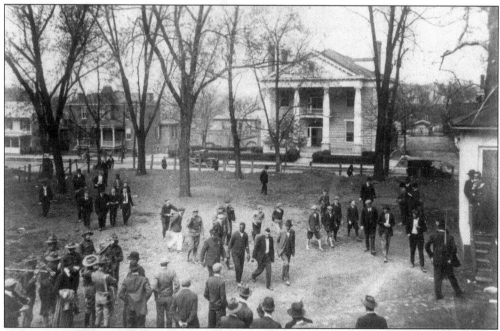

This 1917 photograph shows criminals being walked from the jail through Court Square to court. The building with columns in the background is the Elks Lodge, and to its left in the distance is the jail. (Courtesy of the Albemarle Charlottesville Historical Society, Ferol Briggs Collection.)

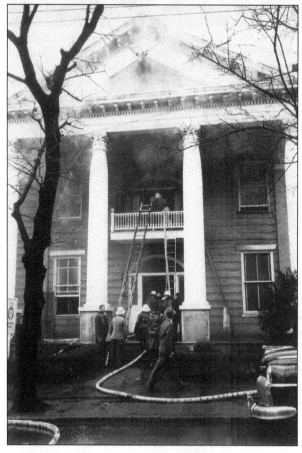

The Benevolent and Protective Order of Elks organized in Charlottesville in 1897 and built Lodge No. 389 in 1902 at 411 East High Street. A dramatic fire swept through the building on March 30, 1960, destroying the portico. The elk in the portico, having survived the fire, was purchased by a local resident. An addition and new portico were constructed on the front of the building in 2010, encapsulating the original building's facade, a section of which is still visible in the new lobby. (Courtesy of the Albemarle Charlottesville Historical Society, Russell "Rip" Payne Collection.)

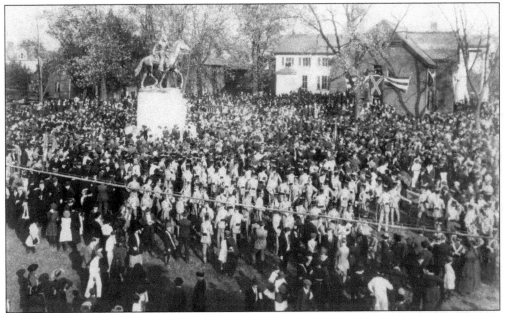

Local residents fill Jackson Park on October 19, 1921, at the dedication of the acclaimed Thomas Jonathan "Stonewall" Jackson statue. The dedication was preceded by a parade and a reunion of Confederate veterans. The statue, sculpted by Charles Keck, was donated by prominent Charlottesville benefactor Paul Goodloe McIntire. The courthouse and old clerk's office are visible in the top right background. (Courtesy of the Albemarle Charlottesville Historical Society.)

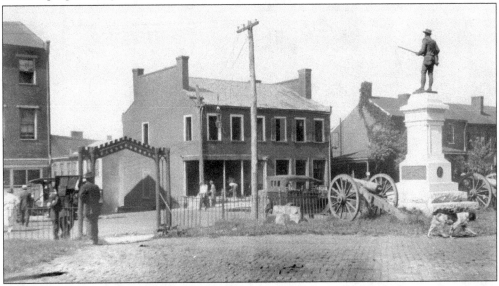

This bronze statue located in Court Square was dedicated on May 5, 1909, to commemorate Charlottesville's Civil War dead. Two bronze cannons and cannonballs stand near the infantryman. The monument was funded by public and private sources and was cast by the American Bronze Company. Statues like this one were mass-produced for monuments in both the North and the South. The view from the square to the southwest shows the gateway to the square and captures renovations being undertaken on the building at the corner of Jefferson and Fifth Streets. (Courtesy of the Albemarle Charlottesville Historical Society.)

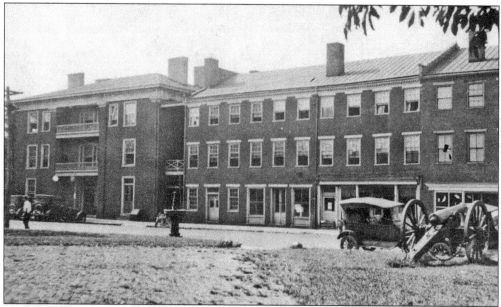

In the late 18th century, the Eagle Tavern was located on the south side of the east end of Jefferson Street. The Eagle was a wood-frame building with a "porch" where merchants gathered to sell goods. The Farish Hotel, constructed on the site around 1860, was renamed the Colonial Hotel around 1903. The Colonial, which operated until the mid-1920s, is pictured here sometime around 1900 at the far left with a row of mercantile buildings extending to the west. (Courtesy of the Albemarle Charlottesville Historical Society, Allaville Magruder Collection.)

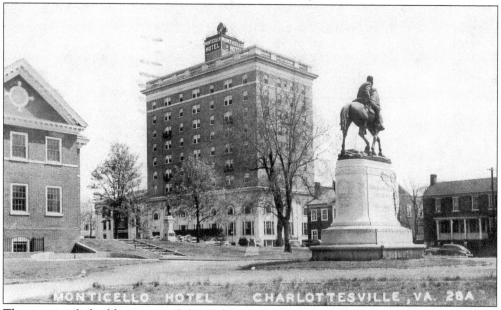

The mercantile buildings west of the Colonial were demolished for the construction of the Monticello Hotel in 1926. Designed by Stanhope Johnson as a nine-story modern luxury hotel befitting its historic setting on Court Square, the hotel was one of Charlottesville's earliest skyscrapers. Its upper levels offered views of Monticello, the Rotunda dome, and the Blue Ridge Mountains. (Courtesy of Preston Coiner.)

Early in Charlottesville's development, public entertainment occurred primarily in taverns, but by the mid-19th century, the need for a building devoted solely to the purpose emerged. In 1852, Town Hall was constructed at the corner of Park and High Streets in the Greek Revival style. It could seat 800 patrons and provided space for concerts, plays, lectures, fairs, and benefits. The property was purchased in the 1880s by Jefferson Monroe Levy, who then owned Monticello, and the building was remodeled and renamed the Levy Opera House. The theater operated until 1912, after which it was used as a school, apartments, and offices. (Courtesy of the Albemarle Charlottesville Historical Society, Allaville Magruder Collection.)

The Martha Jefferson Hospital was organized in 1903 as the Martha Jefferson Sanitarium Association, and this building was constructed in 1904 at the corner of Locust and East High Streets. This image is from 1918, after the second story had been constructed on the front porch. A much larger building designed by Johnson and Brannan was completed in 1929, and the hospital continued to expand through the 20th century. This original hospital building was demolished for today's emergency wing. (Courtesy of Preston Coiner.)

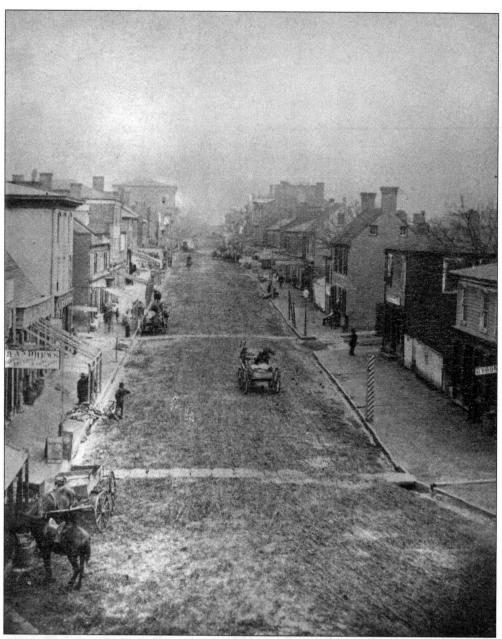

Although 47 town lots had been sold within three years of Charlottesville's establishment in 1762, few had been developed by 1779. By 1800, 47 houses had been erected, and by the 1840s, commercial activity had shifted from Court Square to Main Street. The extent of commercial development is evident in this view taken in the late 1880s looking eastward down Main Street from Vinegar Hill. A mix of brick and frame, two- and three-story buildings is present, but the road is dirt, with stones laid only at intervals as crosswalks. In 1888, the state legislature approved the annexation of property along West Main Street, and Charlottesville became a city. (Courtesy of Visual History Collection [RG-30/1/10.011], Special Collections, University of Virginia Library.)

Two

BECOMING A CITY
CHARLOTTESVILLE AT THE
TURN OF THE 20TH CENTURY

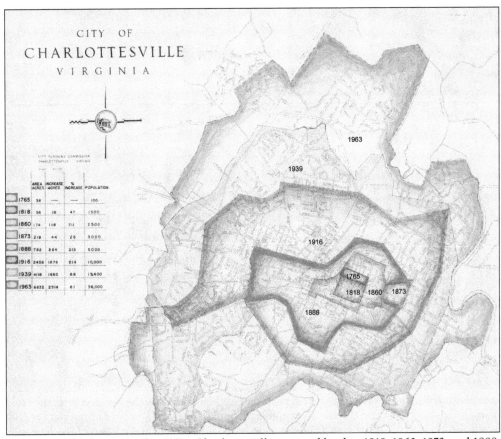

After its establishment in the 1760s, Charlottesville annexed land in 1818, 1860, 1873, and 1888. With the 1888 acquisition, West Main Street was expanded, and Charlottesville's population increased to 5,000, sufficient for the state to designate Charlottesville an independent city. Annexations continued until the Annexation and Revenue Sharing Agreement between the City and Albemarle County was passed in 1982. (Courtesy of the City of Charlottesville, Neighborhood Development Services.)

The Jefferson National Bank opened in 1901 in a building located along the south side of the 100 block of East Main Street. The Greek Revival building, designed by W.T. Vandergrift, featured gray brick and a grand portico of five Ionic columns, as seen in this photograph. The bank was converted to the Jefferson Theater by 1913. After a fire in 1915, the theater was rebuilt according to the plans of Claude K. Howell in the Jeffersonian Classical Revival style. (Courtesy of the Albemarle Charlottesville Historical Society, Allaville Magruder Collection.)

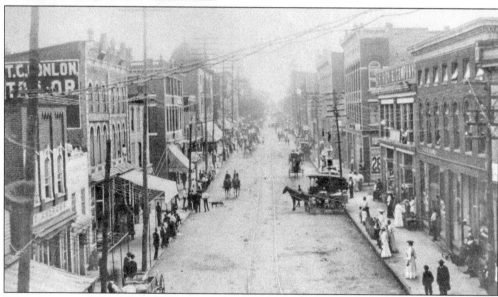

Extensive commercial development was in place on East Main Street by the first decade of the 20th century. Blocks of two- and three-story commercial buildings extend eastward from old Preston Avenue in this c. 1901–1909 view facing east on East Main Street. The portico of the Jefferson National Bank is barely visible near the center of the photograph on the right side of the street. The J.R. Hidy and Company Department Store is visible at the right. "Quick sales for cash and small profits" was the key to Hidy's success. The Leterman Company, a popular department store that boasted nearly 50,000 square feet of floor space, occupied the domed building on the left side of this photograph. Note the trolley tracks running down the center of Main Street. (Courtesy of Visual History Collection [RG-30/1/10.011], Special Collections, University of Virginia Library.)

The Italianate-style Monticello Bank building was constructed in 1854 at the northwest corner of East Main and Fourth Streets. After investing heavily in Confederate bonds during the Civil War, the bank closed, reopening as the Charlottesville National Bank in 1866. The building was demolished in 1954, as seen below, to make way for the Miller and Rhoads department store. (Right, courtesy of Albemarle Charlottesville Historical Society, Russell "Rip" Payne Collection; below, courtesy of the Albemarle Charlottesville Historical Society.)

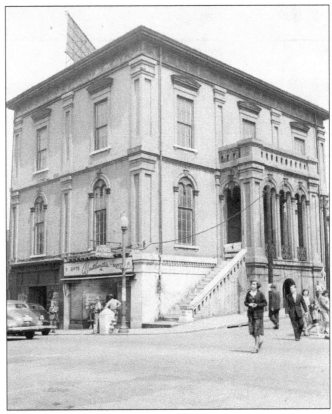

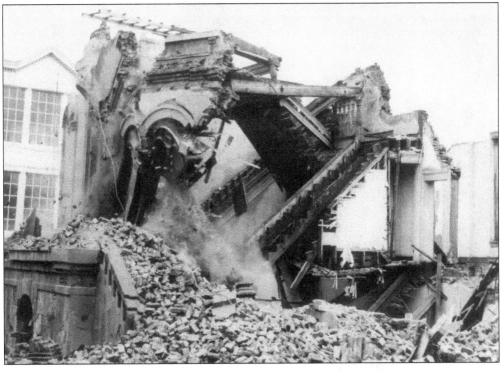

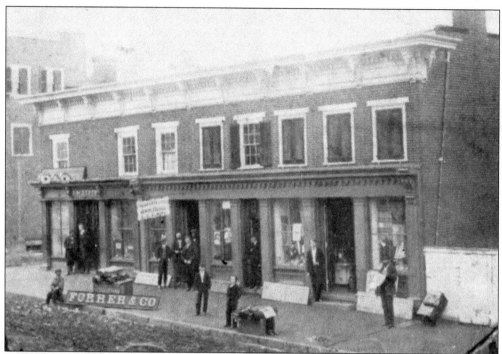

As the commercial center started to shift to East Main Street in the 1840s, James Alexander, editor and publisher of the *Jeffersonian Republican*, purchased the block on the south side of East Main between Third and Fourth Streets in 1844. This building housed three stores at ground level and Alexander's newspaper above. In 1895, the Alexander Block was demolished for the construction of a four-story building for the People's National Bank at the southwest corner of Fourth and Main Streets. (Courtesy of Albemarle Charlottesville Historical Society.)

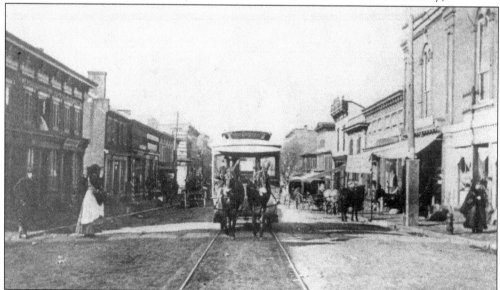

One of Charlottesville's four mule-drawn trolleys travels westward on East Main Street around 1890. The trolley is just passing the Alexander Block on the left and the Monticello Bank on the right. (Courtesy of Albemarle Charlottesville Historical Society.)

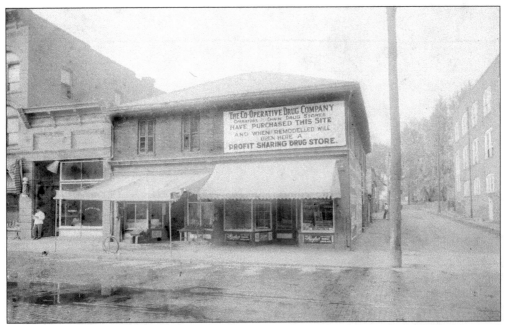

The Cooperative Drug Company, pictured here in 1917, is an early example of a chain store. Located at the corner of Third and Main Streets, the building had previously been occupied by the City Confectionery and was later occupied by the Standard Drug Company. Today's Chap's restaurant and the Rock Paper Scissors store stand on this site. (Courtesy of the Holsinger Collection [MSS 9862], Special Collections, University of Virginia Library.)

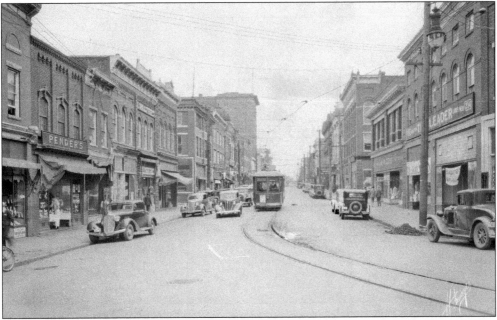

In 1896, the streetcar lines were electrified, and the horses and mules were retired. This post-1920 view of East Main Street looking east from the foot of Vinegar Hill shows the electrified trolley and the eight-story National Bank building in the background on the left. (Courtesy of the Holsinger Collection [MSS 9862], Special Collections, University of Virginia Library.)

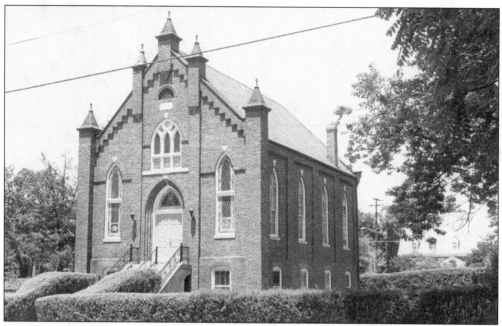

The Congregation Beth Israel's first synagogue was constructed in 1882, but the property was purchased in 1904 by the federal government to establish a post office and federal courthouse. The Gothic-Revival synagogue was reportedly reassembled, brick by brick, at its new location at Jefferson and Third Streets. The synagogue was restored after a 1948 fire, and additions were constructed in 1987 and 1996. (Courtesy of the Albemarle Charlottesville Historical Society, Allaville Magruder Collection.)

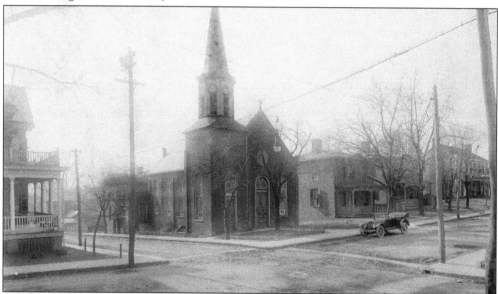

The Church of the Holy Paraclete (Holy Spirit) was constructed for the Catholic congregation of Charlottesville in 1880 on the corner of Jefferson and Third Streets. Note the unpaved streets in this 1917 photograph. In 1925, this structure was replaced by the Holy Comforter Catholic Church that still stands on the site. (Courtesy of the Holsinger Collection [MSS 9862], Special Collections, University of Virginia Library.)

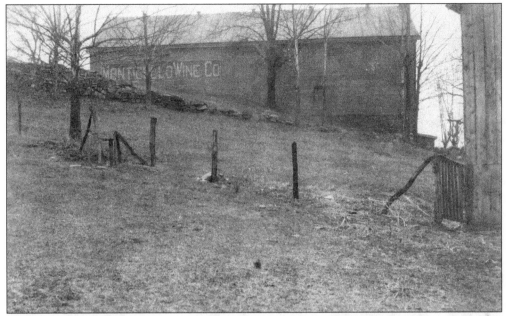

The Monticello Wine Company was founded in the early 1870s and operated on a site located at what is today Perry Drive, north of downtown and east of McIntire Road. This photograph shows the wine cellar in the 1890s. The building was destroyed by fire in 1937. (Courtesy of the Albemarle Charlottesville Historical Society.)

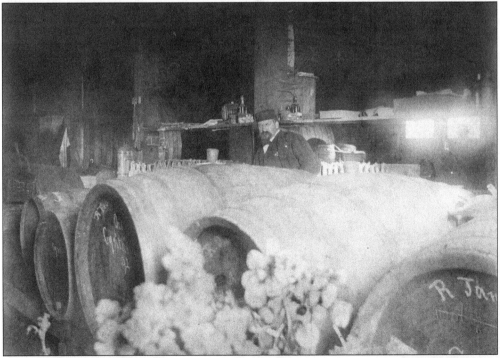

Adolph Russow, shown here in the wine cellar, was the winery's general manager beginning in 1873. Wines produced under his management earned medals in national and international competitions. (Courtesy of the Albemarle Charlottesville Historical Society.)

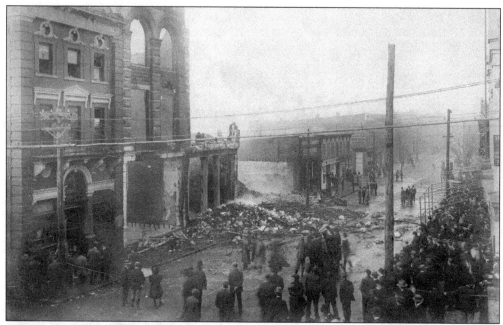

A fire in 1909 destroyed a significant part of the 300 block of East Main Street. In the image above, the People's National Bank building, constructed in 1895, is shown at the far left; the one-story ruins are all that remained of the Charlottesville Hardware store. The image below shows the reconstructed block in 1918. The hardware store was rebuilt (third building from the left), and the bank building was reduced to a two-story structure. In 1917, People's moved out, and Timberlake's drugstore moved in. The storefront was remodeled to accommodate large display windows, but the grand lobby space was retained for store use. In 1956, the facade was remodeled to resemble its pre-1917 design, and a third story was recently added for residential use. (Above, courtesy of the Albemarle Charlottesville Historical Society; below, courtesy of the Holsinger Collection [MSS 9862], Special Collections, University of Virginia Library.)

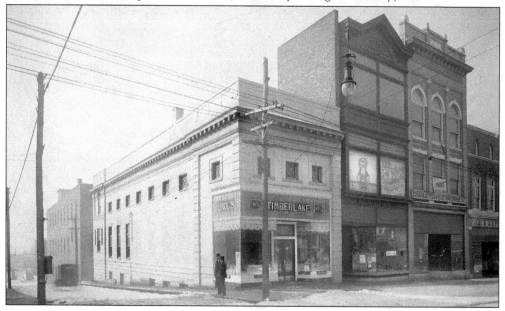

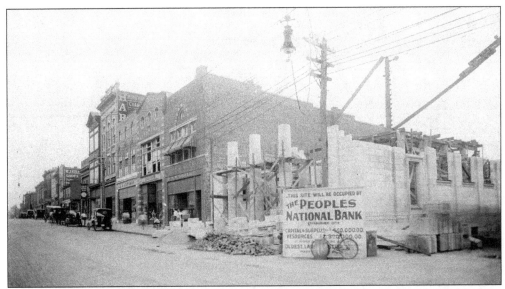

People's National Bank hired local architect Eugene Bradbury to design a new building at the southeast corner of Third and East Main Streets. This 1916 photograph shows construction well underway, with the columns of the portico in place. The bank's previous location is just barely visible at the end of the block. In between are buildings reconstructed after the 1909 fire. (Courtesy of the Holsinger Collection [MSS 9862], Special Collections, University of Virginia Library.)

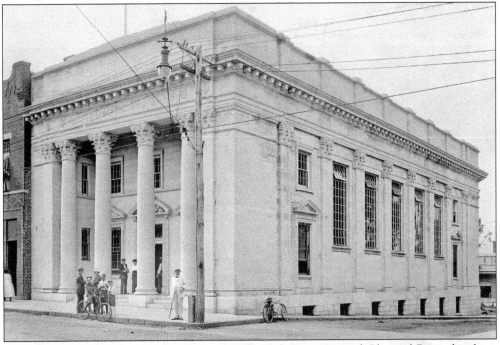

A competitor of the National Bank, People's chose the monumental Classical Revival style to express the institution's strength and stability. The granite Corinthian columns of the portico are echoed by double-height pilasters on the side elevation, where large windows lit the grand banking hall. (Courtesy of the Holsinger Collection [MSS 9862], Special Collections, University of Virginia Library.)

This residence was located at the northwest corner of Second and East Main Streets. It is said to have been occupied by a Colonel Taliaferro, then a Colonel Bell, after which it became the Scott family home. Mr. Scott, a free African American, is shown standing on his steps. The house was demolished in 1892 to construct the Rosser Building, shown below in 1914 before the National Bank purchased the structure. (Above, courtesy of Visual History Collection [RG-30/1/10.011], Special Collections, University of Virginia Library; below, courtesy of the Holsinger Collection [MSS 9862], Special Collections, University of Virginia Library.)

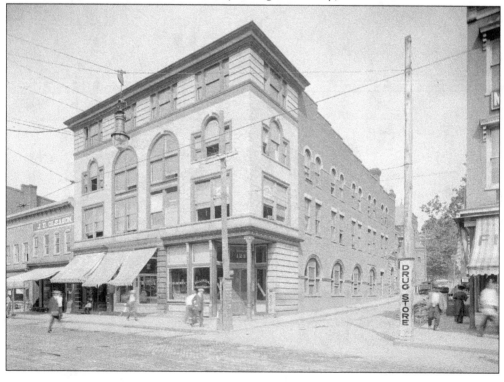

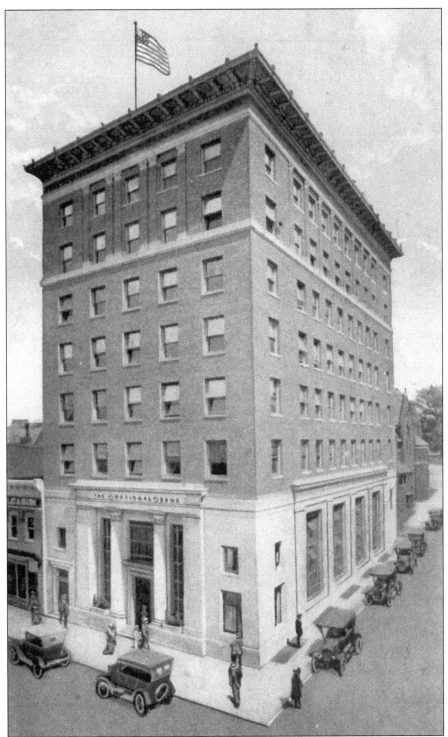

The National Bank, founded in 1914, constructed this building by 1920 on the site of the former Rosser Building. Designed by Washington, DC architects Marsh and Peter, the eight-story building was Charlottesville's tallest structure to date. (Courtesy of Preston Coiner.)

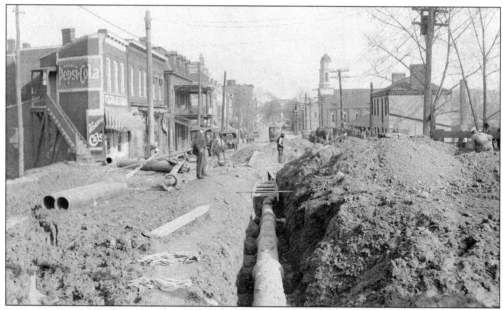

The Southern Railroad undertook excavations along West Main Street in 1918. This view looking east shows First Baptist Church, with its distinctive bell tower, on the right side of the street. In 1863, 800 African Americans, previously not allowed to establish independent churches, split from the Charlottesville Baptist Church and founded a separate congregation. They purchased the property in 1868, then occupied by the Delevan House, which was used as a hotel, a boy's school, a Civil War hospital, and a free school for African Americans. The building was condemned in 1876 and construction on today's church began. After the first service was held in 1884, the name changed from the Delevan Church to the First Colored Baptist Church. The two-story porch of the Clermont Hotel is visible beyond the men on the left side of the street. (Courtesy of the Holsinger Collection [MSS 9862], Special Collections, University of Virginia Library.)

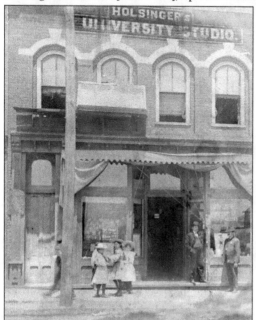

Rufus W. Holsinger arrived in Charlottesville in the late 1880s and established a successful photography business. Holsinger used the wet-plate method and large negatives, resulting in extremely sharp images. He covered a wide range of subjects, from everyday occurrences to major events, including the burning of the Rotunda and the image of Monticello used for the $2 bill. A 1910 studio fire destroyed many of his negatives, and a fall from a second-story studio window resulted in injuries that ended his career in 1915, after which his son, Ralph, took over. This photograph shows Holsinger's 719–721 West Main Street studio in 1902. (Courtesy of the Albemarle Charlottesville Historical Society.)

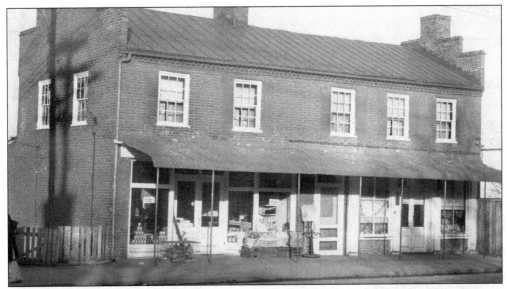

The oldest part of 333 West Main Street was constructed as a residence by 1820. In 1891, prominent African American resident George P. Inge opened a grocery store on the first floor and lived with his family on the second story. The mixed-use residential-and-commercial building was common during this period and the stepped gables are also typical of Charlottesville's early brick structures. Inge's Market served as a social center for the Vinegar Hill neighborhood. George's son Thomas continued the grocery business after the elder Inge retired. The store closed in 1980 and now houses the West Main restaurant. (Courtesy of the Albemarle Charlottesville Historical Society.)

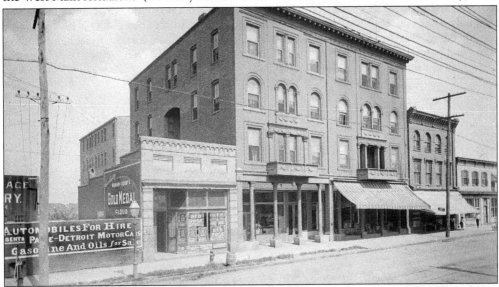

In 1889, Michael S. Gleason built the three-story structure shown here on the right, which housed a grocery, a bar, and rooms for rent. In 1896, he built the four-story Gleason Hotel. The Gleason was extremely successful, in large part due to its proximity to the Southern Railroad station. In 1915, the year this photograph was taken and five years after Gleason's death, the earlier structure became a coffee shop for the hotel. In 1933, the hotel changed hands and was renamed the Albemarle Hotel. The coffee shop eventually became the Gaslight restaurant. (Courtesy of the Holsinger Collection [MSS 9862], Special Collections, University of Virginia Library.)

The King Lumber Company, shown above on the right, was established by Walter William King on Preston Avenue in 1899. King supplied building materials for construction projects both locally and nationwide. In 1916, Preston Avenue was still relatively undeveloped. By 1919, however, several residences had been constructed beyond the lumber company. In that year, the Southern Railroad completed a new bridge over Preston Avenue at the corner of the King property, and the road was paved. The building in the right foreground of the lower image was originally constructed as King's residence (1909) and was intended to be a model of his company's high-quality work. After 1947, the house became the Carver Inn, an African American boarding house and hotel. (Both, courtesy of the Holsinger Collection [MSS 9862], Special Collections, University of Virginia Library.)

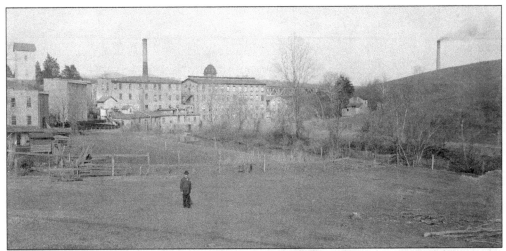

In the late 1860s, the Charlottesville Woolen Mills opened as a reincarnation of the Charlottesville Manufacturing Company, which had been burned accidentally by the Union Army in 1865. The Woolen Mills specialized in the production of high quality woolens, particularly for uniforms, throughout the late 19th and early 20th centuries. In this 1916 image, Woolen Mills president Robert Poore Valentine poses in front of the extensive mill complex. (Courtesy of the Albemarle Charlottesville Historical Society.)

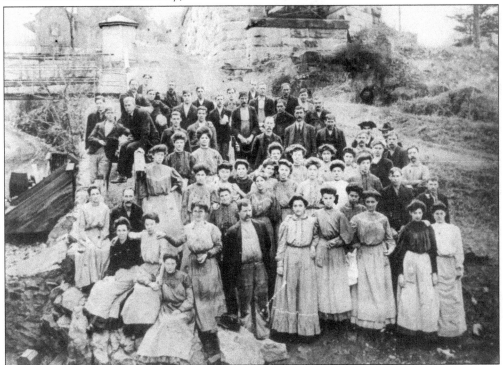

A community of workers, managers, and owners developed around the Woolen Mills. Located roughly one mile east of Charlottesville's Court Square, it had its own school, a store, worker housing, and a church. In this image, workers and residents pose at the mill around 1913. The mill operated until 1964, when the property was sold to a moving and storage company. (Courtesy of the Albemarle Charlottesville Historical Society.)

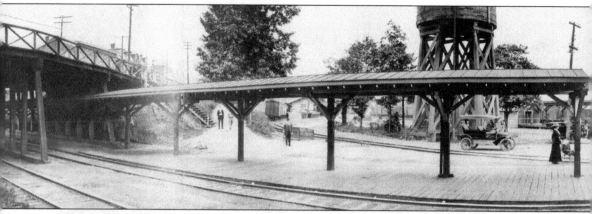

The Louisa Railroad (later the Chesapeake and Ohio or C&O) came to Albemarle County in the 1840s, and by the Civil War, Charlottesville had reliable train service. Situated at the junction of two main lines (the Southern Railway running north-south and the C&O running east-west), rail service spurred development in Charlottesville. The Southern Railway's Union Station was

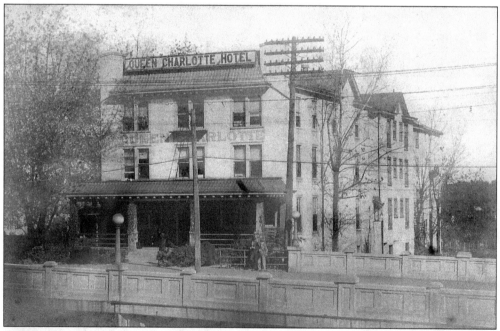

The Queen Charlotte Hotel stood on the north side of West Main Street across from Union Station. Initially, the Peyton family opened their home to travelers, and the establishment became so popular that a large addition was constructed on the front of the house. By the early 20th century, West Main Street had developed into the principal hotel district. This c. 1915 view shows the hotel before the fourth story was added. As with the Gleason Hotel, the Queen Charlotte declined in tandem with railroad traffic. The building was demolished in 1955. (Courtesy of Preston Coiner.)

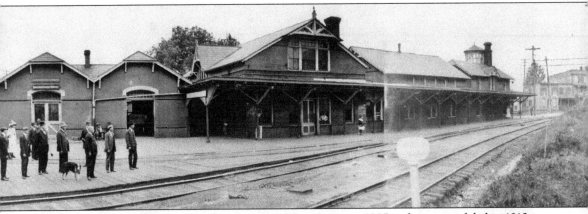

constructed at the junction of the lines on West Main Street in 1885 and was remodeled in 1913. This pre-1916 panorama shows the station, its canopy, a water tower, and the wooden bridge carrying West Main Street over the Southern's tracks. (Courtesy of the Library of Congress, Prints and Photographs Division, [LC-USZ62-125528].)

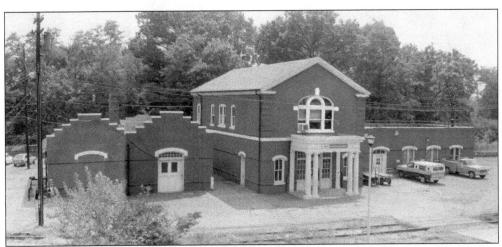

The main buildings for the Southern Railroad's Union Station, today's Amtrak Station, still stand. As interest in rail travel has increased in recent years, Charlottesville's Union Station has become a popular destination for both train travelers and diners at the Wild Wing Cafe, which opened in the main building in 1991. (Courtesy of the Albemarle Charlottesville Historical Society, Allaville Magruder Collection.)

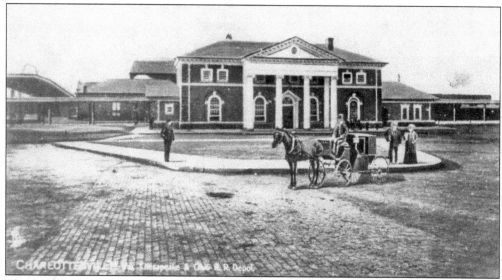

The C&O Railroad constructed a wood-frame train station at the east end of Main Street in 1883. The station pictured here was built in 1905 to replace the earlier building. This postcard shows the street side of the station with its entrance lawn. The carriage and passengers were drawn in by the postcard artist Raphael Tuck and Sons. The original Belmont Bridge is seen at the far left. The passenger station closed in 1982, and a series of renovations and additions converted the building to offices in 1990. The cast-iron columns of the station canopy remain between the office's bay windows. (Courtesy of Visual History Collection [RH-30/1/10.011], Special Collections, University of Virginia Library.)

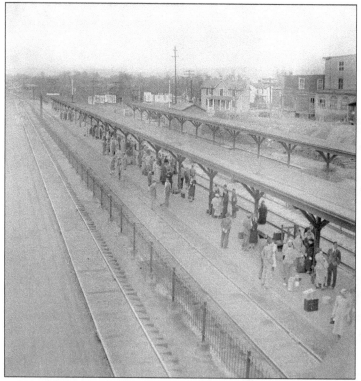

Passengers wait for trains to arrive at Charlottesville's Union Station around 1940. During this period, three canopies extended from the station northward along the tracks and under the Main Street bridge. (Courtesy of Visual History Collection [RH-30/1/10.011], Special Collections, University of Virginia Library.)

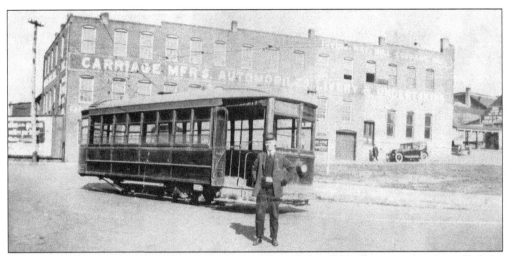

Charlottesville's first street railway company was chartered in 1887. Horses and mules pulled the trolley cars from the C&O station to the University. In 1894, a competing electrified line opened. The two operated side by side for a time, then merged in 1896 and became the Charlottesville City and Suburban Railway Company. Various lines were extended from the main line, including lines to Fry's Spring in the late 1890s, to the Rotunda in 1912 (which the students protested), and to Rugby Road in 1914. During this period, Bayard S. Maupin was reportedly the most popular conductor, and he is pictured here in 1912 by the C&O depot. In 1935, the trolleys were replaced with buses. (Courtesy of Preston Coiner.)

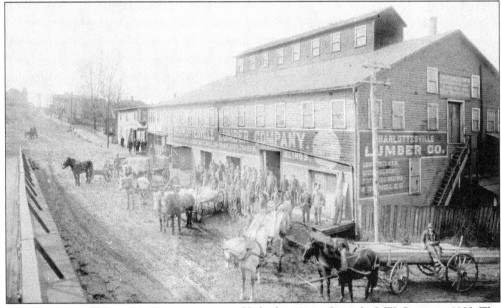

The Charlottesville Lumber Company was established on Avon Street by L.W. Graves in 1893. The company provided building materials and acted as a general contractor for many of Charlottesville's residential subdivisions, schools, and churches. The business expanded significantly in the second half of the 20th century, changing its name to Better Living and moving large parts of the company to Route 29 North. This 1917 image shows the railing of the Belmont Bridge along the far left. The building was demolished in late 2009. (Courtesy of Holsinger Collection, Special Collections, University of Virginia Library.)

The public school system was established in Virginia in 1870. A public grade school, under the jurisdiction of Albemarle County, was established in the town of Charlottesville in that year. This school, located on Garrett Street, housed three different grade levels and is said to have been the first public school building for white students in Charlottesville. The photograph dates to 1936, but the building stopped being used as a school much earlier. (Courtesy of the Albemarle Charlottesville Historical Society.)

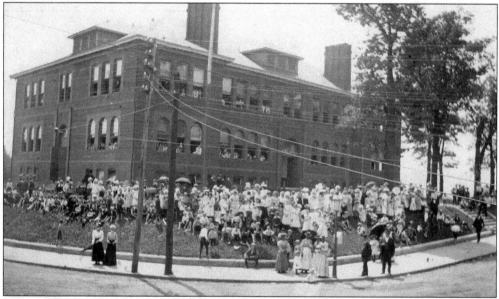

In 1877, the town of Charlottesville established an all-white high school in the Midway House, a building originally constructed as a hotel in 1828 at the corner of Ridge and Main Streets. The school operated for five years, then lost funding. In 1889, the city of Charlottesville elected its own school board and restarted classes at Midway in 1890. In 1893, the hotel building was replaced with a new school building for both elementary and high school students. In 1916, the elementary students moved to the new McGuffey School, and in 1939, high school students moved to a new building on Preston Avenue. This photograph captures Circus Day at Midway School in the early 1900s. (Courtesy of the Albemarle Charlottesville Historical Society.)

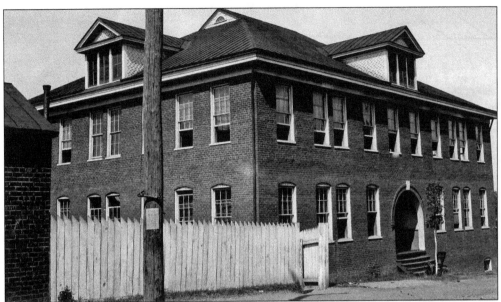

In 1894, the African American Jefferson Graded School was constructed on Fourth Street NW between Commerce and Brown Streets. Jefferson initially included only grades one through six. Grades seven and eight were added later, but African American high school students had to attend schools outside the area until Jefferson High School was constructed near this site in 1925. The Jefferson Graded School building, shown here in 1921, was demolished in 1960. (Courtesy of Jackson Davis Papers, Accession #3072, Special Collections, University of Virginia Library.)

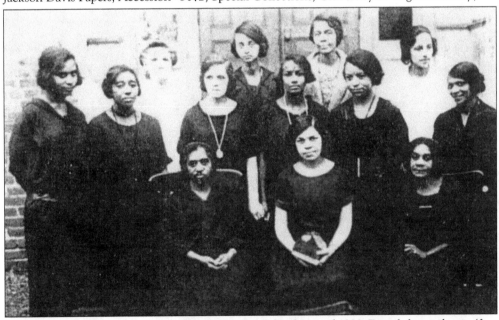

This image shows teachers at the Jefferson Graded School around 1920. From left to right are (first row) Maggie Terry, Maude Gamble, and Cora Duke; (second row) Ella Baylor, Rebecca McGinnis, Peachie Jackson, Kathleen Chisholm, Carrie Michie, and Gertrude Inge; (third row) Nannie Cox Jackson, Marian Wyatt, Jane C. Johnson, and Helen Jackson. (Courtesy of the Albemarle Charlottesville Historical Society.)

The McIntire Building on the southeast corner of Jefferson and Second Streets across from Lee Park was funded by Paul Goodloe McIntire. Constructed as a public library for Charlottesville, it was designed by Walter Dabney Blair in the Neoclassical Revival style, featuring a semi-circular portico and flanking niches. The building was dedicated in 1922 and housed the library until 1981. In 1994, it became the home of the Albemarle Charlottesville Historical Society. (Courtesy of the Albemarle Charlottesville Historical Society, Allaville Magruder Collection.)

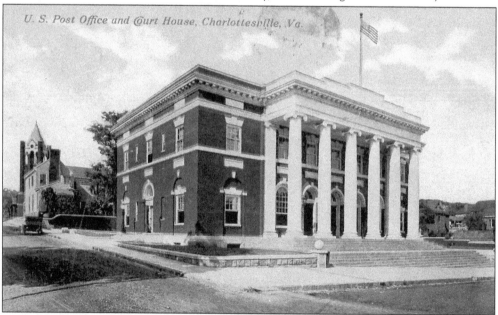

In 1906, construction began on Charlottesville's new Federal Building on the former site of the Jewish synagogue. The Federal Building housed a post office on the ground floor and courthouse space above. When the structure was enlarged in the 1930s, the portico was re-centered. The building operated in its original capacity until 1980, then became the home of the public library. (Courtesy of Preston Coiner.)

Three

THE FOUNDING OF AN INSTITUTION
THE UNIVERSITY OF VIRGINIA

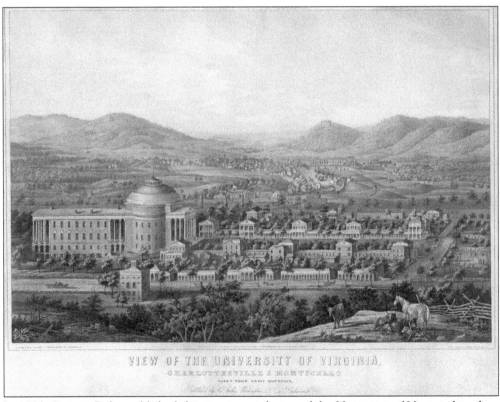

In 1856, Casimir Bohn published this iconic aerial view of the University of Virginia based on Edward Sachse and Company's engraving. The view is from Lewis Mountain, located west of the University, and shows Charlottesville in the distance. The scale of the Rotunda and its Annex, a later addition to Jefferson's design, are greatly exaggerated in this perspective. (Courtesy of a private collection.)

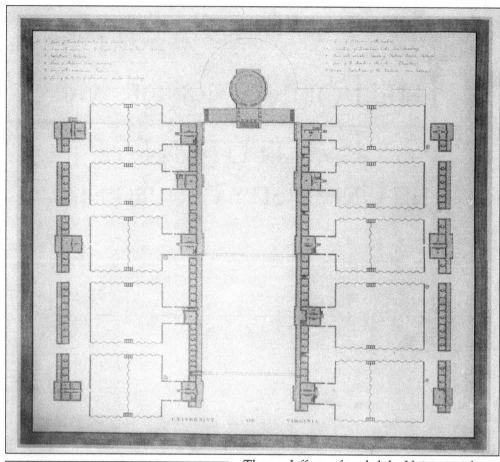

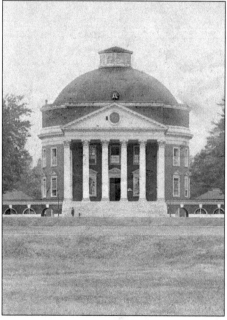

Thomas Jefferson founded the University of Virginia in 1819 and designed the layout of its Academical Village. Peter Maverick engraved this plan of the Lawn in 1822, based on a plan drafted by John Neilson, one of Jefferson's master carpenters. The plan shows the 10 pavilions linked by dorm rooms, with the Rotunda located at the north end. The east and west ranges are also shown beyond the serpentine walls and gardens. (Courtesy of Special Collections [MSS 6552], University of Virginia Library.)

With assistance from Benjamin Henry Latrobe, architect for the US Capitol, Jefferson designed the Rotunda, originally a library and lecture hall, as the centerpiece of his Academical Village. The Rotunda, completed in 1826, is a half-scaled interpretation of the Roman Pantheon. This image shows the south portico before the 1895 fire. Note the dark patina of the dome. (Courtesy of the Albemarle Charlottesville Historical Society.)

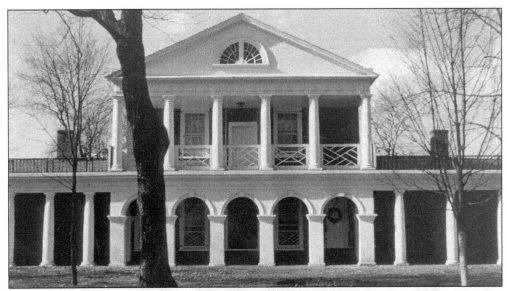

Pavilion VII was the first building constructed on the Lawn. The cornerstone was laid on October 6, 1817, with Jefferson, Madison, and Monroe in attendance. Jefferson's design for this pavilion combines "Doric Palladio" with suggestions by his colleague, architect William Thornton. The result is a double-height portico of six Doric columns supported by a five-bay arcade. This pavilion served as the first library, and since 1907, it has been home to the Colonnade Club. (Courtesy of the Albemarle Charlottesville Historical Society, Allaville Magruder Collection.)

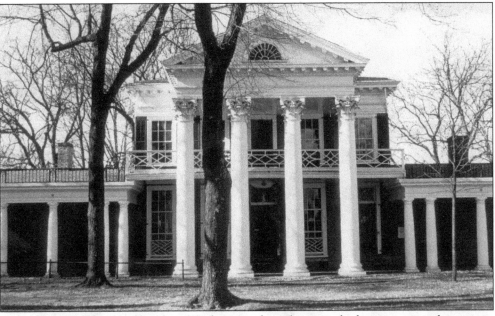

The compressed facade of Pavilion III, the second pavilion on which construction began, was the result of Jefferson's addition of two pavilions to the plan of the Lawn in 1818. The double-height columns, a suggestion by Benjamin Henry Latrobe, are topped with Corinthian capitals carved from Italian Carrara marble. Pavilion III briefly housed the University's first law professor; after 1830, it was used for administrative offices and seminar rooms. (Courtesy of the Albemarle Charlottesville Historical Society, Allaville Magruder Collection.)

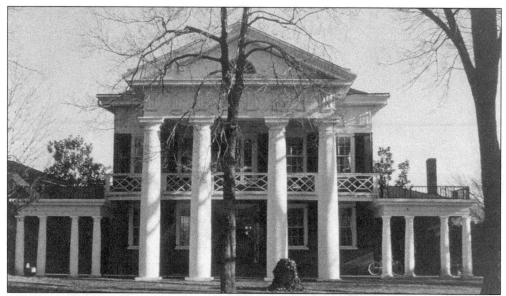

Jefferson based the Doric order columns and entablature for Pavilion X, the last pavilion to be constructed, on the Roman Theater of Marcellus. Originally, a wooden parapet hid the roof, but due to damage (most likely from drainage problems), it was removed in 1870. Dr. Dunglison, the first professor of medicine at an American university and Jefferson's physician at the time of his death in 1826, was the first resident in this pavilion. (Courtesy of the Albemarle Charlottesville Historical Society, Allaville Magruder Collection.)

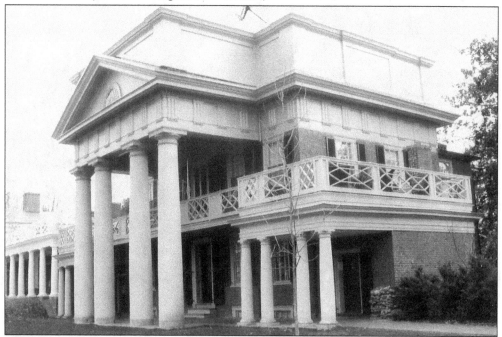

Pavilion X was restored to its Jeffersonian-era design in 2009. The approximately eight-foot-high parapet was reconstructed on the roof, the columns were returned to their original stucco finish, the Chinese railings above the student rooms were replaced and painted a sandstone color, and the shutters were returned to their original green. (Courtesy of Brian Painter.)

Dr. Dunglison, dissatisfied with performing dissections in the front room of Pavilion X, asked Jefferson to construct a new building with theater seating more conducive to teaching anatomy. Jefferson obliged and designed the Anatomical Theater in 1825, locating a skylight over the dissection table and lunette windows above eye-level to allow light to enter the theater while keeping out the public gaze. This image shows the UVa Medical School class of 1873 posing in front of the entrance along McCormick Road. The building suffered a fire in 1886 and was subsequently reconstructed. In 1939, the Anatomical Theater was demolished, the only Jefferson building at the University ever to be razed. (Courtesy of Visual History Collection [RG-30/1/10.011], Special Collections, University of Virginia.)

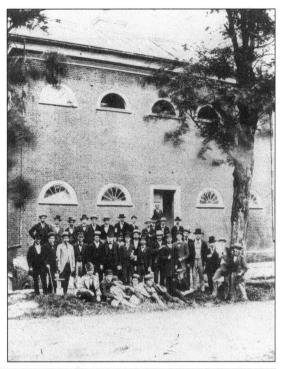

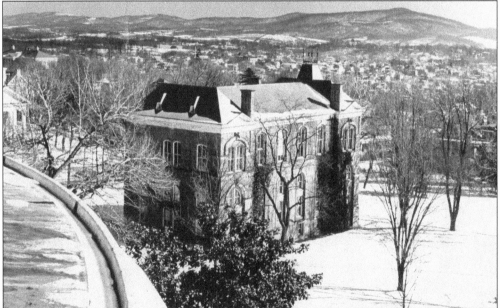

Originally a natural science museum, Brooks Hall was donated to the University by Lewis Brooks, a wealthy industrialist from Rochester, New York. Designed by John Rochester Thomas, a prominent architect also from Rochester, the structure was located northeast of the Rotunda and completed in 1877. Thomas designed the building in the highly fashionable ornate Second Empire style, complete with a mansard roof and decorative elements indicating the building's function as a science museum, such as the animal head carvings in the keystones of the window arches. This photograph was taken from the roof of the Rotunda around 1960. (Courtesy of Ed Roseberry.)

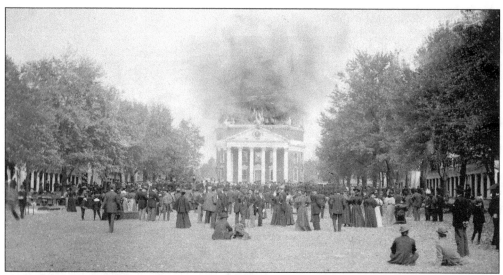

On October 27, 1895, a fire began in the northwestern portion of the Annex. The flames quickly consumed the Annex and threatened the Rotunda. While townspeople and students threw books from the Rotunda windows into blankets below, Professor Echols dumped 50 pounds of dynamite on the bridge connecting the Annex and Rotunda in an effort to retard the flames, causing an explosion that shattered nearly every pane of glass in the Rotunda. Shortly thereafter, a change in wind held back the flames and spared the rest of Jefferson's Lawn. A few hours later the roof of the Rotunda collapsed, along with the entire south portico, except the columns. (Courtesy of Holsinger Collection, Special Collections, University of Virginia.)

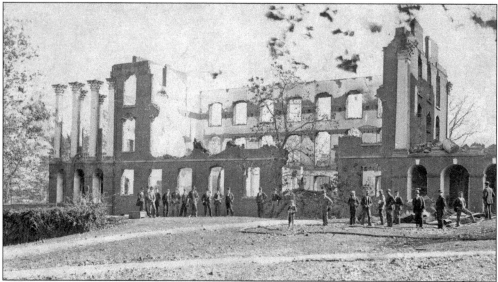

The Jefferson-trained neoclassical architect Robert Mills was commissioned to design the Annex in 1851 when the growth of the University necessitated more classroom space. Equipped with a seating hall for 1,200 people, the scale of the Annex overwhelmed the Rotunda, and it was not reconstructed after the fire. This image shows the shell of the Annex after the fire. On the north end of the Annex facing University Avenue stand Mills's columns, with cast-iron Corinthian capitals, which differed from the Carrara marble Jefferson used for his columns on the south portico. (Courtesy of Holsinger Collection, Special Collections, University of Virginia.)

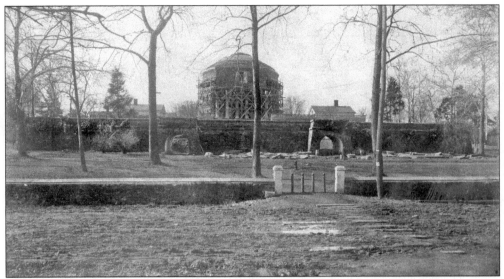

This image shows the scaffolding and reconstruction of the Rotunda after the fire from University Avenue, then an unpaved road. The foundation of the Annex, located in front of the Rotunda in this photograph, had not yet been demolished. The prominent New York architectural firm, McKim, Mead, and White, was commissioned to reconstruct the Rotunda. (Courtesy of Visual History Collection [RG-30/1/10.011], Special Collections, University of Virginia.)

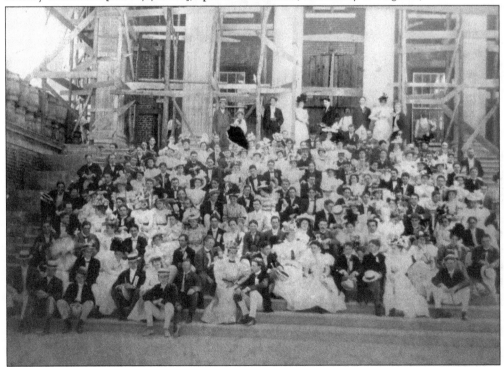

It was common for students and townspeople to pose for group pictures on the steps of the Rotunda during its reconstruction. This image shows a group gathered on the steps of the south portico with the scaffolding visible in the background. (Courtesy of the Albemarle Charlottesville Historical Society.)

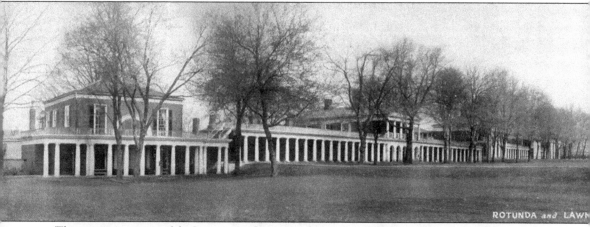

This panoramic view of the Lawn was taken around 1915. Pavilion IX, shown on the left, is arguably the most famous of all the pavilions. The recessed entrance niche is most notable, the design of which has been attributed to several sources, including the avant-garde French neoclassical architect Claude-Nicholas Ledoux's Parisian Hotel de Guimard. However, its source may also have

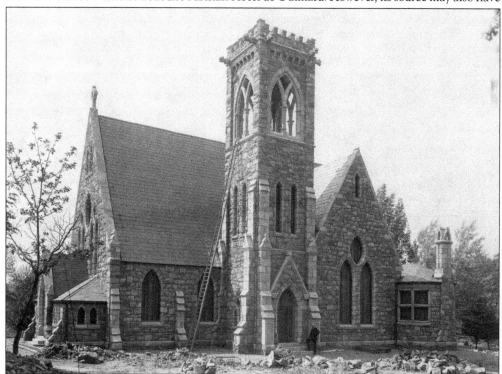

For 50 years, the issue of where and in what style to build a chapel on Grounds plagued the University. Many thought the chapel should be designed in a classical style akin to Jefferson's Academical Village, or that it should be located at the south end of the Lawn to properly enclose the space. Finally, in the 1880s, the Board of Visitors voted to locate the new Gothic Revival chapel, designed by Charles E. Cassell, northwest of the Rotunda to balance the location of Brooks Hall, constructed a decade earlier. This image shows the chapel in 1889 during the final stage of construction. (Courtesy of Visual History Collection [RG-30/1/10.011], Special Collections, University of Virginia Library.)

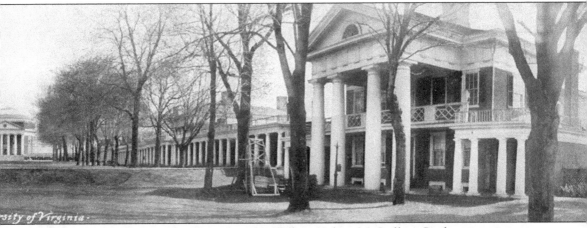

been a suggestion by Benjamin Henry Latrobe. William Holmes McGuffey, a Presbyterian minister and the University's first chaplain, was the second resident to live in Pavilion IX. (Courtesy of the Albemarle Charlottesville Historical Society.)

McKim, Mead, and White designed Cabell Hall in 1896. The controversial location incited debate over Jefferson's intent for the open view, which he believed represented the limitless freedom of the human mind. However, at the behest of W.C.N. Randolph, Jefferson's great-grandson and the rector of the University, the building was located at the south end of the Lawn. Filling in the south end not only obstructed the view of the mountains, but also obscured from view an African American neighborhood deemed unsightly by University officials of the day. This image of Cabell Hall was taken from the south portico of the Rotunda. (Courtesy of the Albemarle Charlottesville Historical Society, Allaville Magruder Collection.)

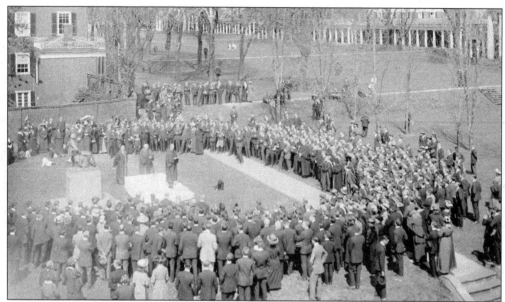

On Founder's Day, April 14, 1915, the US Secretary of Agriculture David F. Houston presented a bronze statue of a seated Thomas Jefferson to the University. Chicago industrialist Charles R. Crane had commissioned Karl Bitter (a prominent Viennese sculptor who had worked at the 1893 World's Columbian Exposition in Chicago) to sculpt the statue as a gift to the University. Bitter modeled the piece on a marble statue he had sculpted previously for the 1904 World's Fair in St. Louis. University president Edwin Alderman led the procession of faculty and students to the unveiling ceremony. (Courtesy of Holsinger Collection [MSS 9862], Special Collections, University of Virginia Library.)

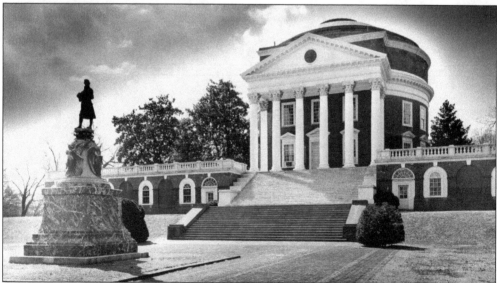

This image shows McKim, Mead, and White's Rotunda dome, terraces, north portico, and grand flight of stairs. The Jefferson statue in front of the stairs was presented to the University by Richmond-born sculptor Moses Ezekiel in 1910. Jefferson is depicted standing on top of the Liberty Bell with the Declaration of Independence in hand. Figures representing Justice, Human Freedom, Religious Freedom, and Liberty circumscribe the bell. (Courtesy of Ed Roseberry.)

Edwin Anderson Alderman was appointed the first president of the University of Virginia after the Board of Visitors created the position in 1904. Alderman, a progressive and dynamic leader, served for 27 years. He established many of the professional schools, including the Curry School of Education and the McIntire School of Art and Architecture, and worked to physically expand the University beyond the Lawn. Among the buildings constructed during his tenure were Monroe Hall, Peabody Hall, and Minor Hall. (Courtesy of Holsinger Collection [MSS 9862], Special Collections, University of Virginia Library.)

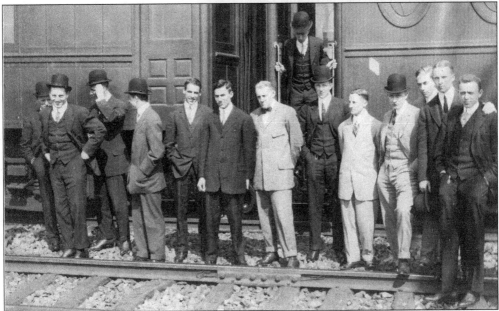

Students pose in front of a train in Charlottesville around 1900. The coming of the railroad to Charlottesville in the 1860s spurred an increase in the student population, and, in turn, the expansion of the University. Note the first-year students identifiable by their felt hats, a tradition that persisted until the 1940s. It was customary for first-year students to wear felt or straw hats throughout the year, which they would tip or remove upon passing a professor. (Courtesy of Visual History Collection [RG-30/1/10.011], Special Collections, University of Virginia Library.)

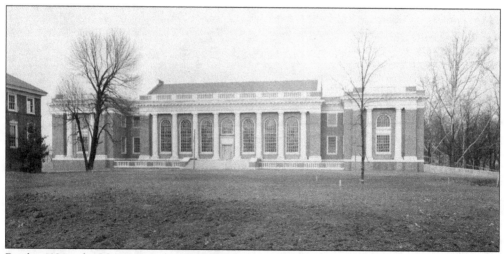

By the 1930s, the University's library had outgrown the limited space in the Rotunda. Shortly before his death in 1931, Alderman called for a new library to be constructed. Alderman Library, dedicated to the University's first president, was completed in 1938 and designed by R.E. Lee Taylor, an alumnus and former member of the University's Architectural Commission. In order to minimize the scale of the five-story building in relation to the Lawn, Taylor tucked the structure into the steep slope of the site, achieving a two-story facade for the south elevation. The University's Architectural Commission rejected this scheme, submitted by an architect in 1935, in favor of a less monumental design. (Courtesy of Visual History Collection [RG-30/1/10.011], Special Collections, University of Virginia Library.)

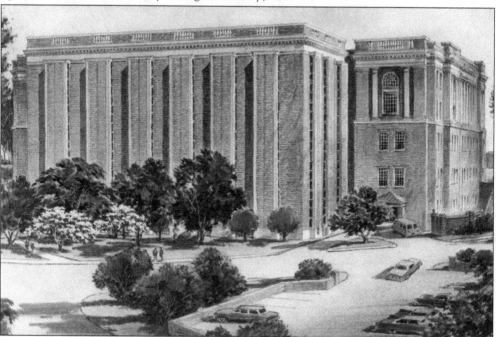

This perspective drawing of Alderman Library shows J. Russell Bailey's 1967 addition to add more stack space. The addition covered most of the north façade of the original library facing University Avenue. (Courtesy of Visual History Collection [RG-30/1/10.011], Special Collections, University of Virginia Library.)

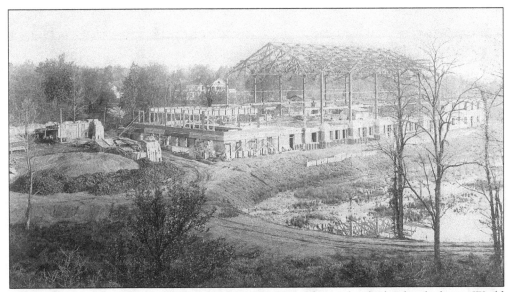

Memorial Gymnasium, named in honor of the 66 UVa students who died in battle during World War I, was constructed in response to the substantial growth of the University in the early 20th century. By the 1920s, the University had outgrown Fayerweather Hall, the first building constructed as a gym, and the Architectural Commission headed by Fiske Kimball was established to oversee the design and construction of a new gym. Kimball had been appointed head of the new McIntire School of Fine Arts in 1919, which moved into Fayerweather Hall upon completion of Memorial Gym. The excavated area east of the gym became a reflecting pool. (Courtesy of Jane Beckert.)

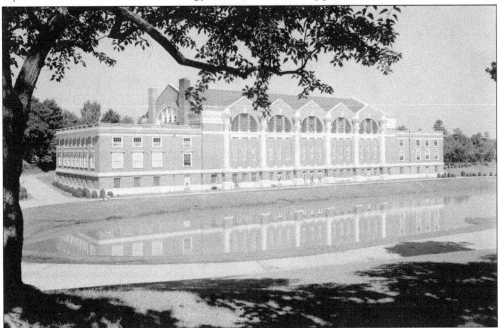

Memorial Gym was completed in 1924. With its five bays divided by colossal Corinthian columns, the building embodies the elegant classicism indicative of the American Renaissance period of architecture. In 1952, the reflecting pool was drained and replaced by a parking lot. (Courtesy of Holsinger Collection [MSS 9862], Special Collections, University of Virginia Library, Holsinger Collection.)

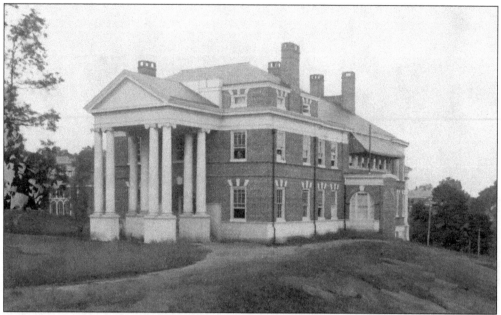

The Old University Hospital originally consisted of a single building situated parallel to the East Range, as shown in this 1902 image. Dr. Paul Barringer, chairman of the faculty, pressed to create the hospital, which rapidly expanded. A series of modular pavilions was added onto the north and south sides of the building in the early 20th century, all of which would be subsumed by further expansions in the 1940s. (Courtesy of the Albemarle Charlottesville Historical Society.)

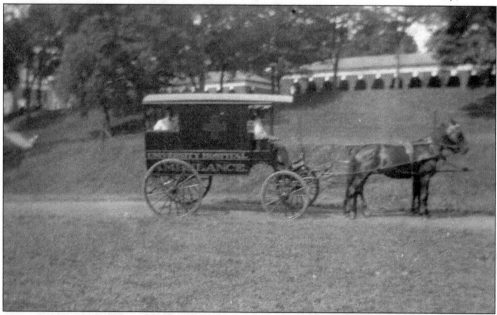

Nicknamed the "Stiff Wagon" and driven by an African American man named Esau, this horse and carriage hauled cadavers from the hospital to the Anatomical Theater, and later to "Stiff Hall," located in the vicinity of what is today Newcomb Hall, for medical students to study. Note the East Range in the background and one of the hospital pavilions behind the trees at the left. (Courtesy of the Albemarle Charlottesville Historical Society.)

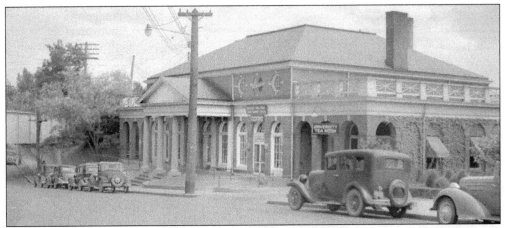

The Corner Building, initially referred to as the Entrance Building, was designed by local architect Eugene Bradbury and completed in 1914. The building originally housed the University's post office, a tearoom, and shops. This image shows the elegant neo-Jeffersonian building in its original location farther west on University Avenue, before it was moved to make way for the Medical School Building in the late 1920s. This building now houses administrative offices and the UVa Women's Center. (Courtesy of Visual History Collection [RG-30/1/10.011], Special Collections, University of Virginia Library.)

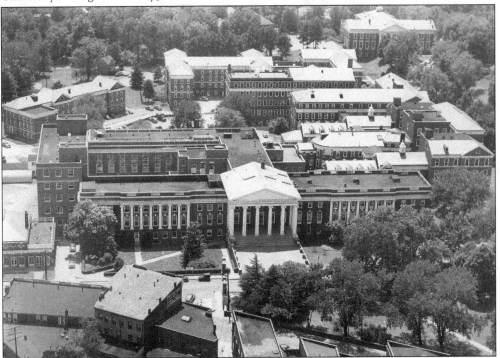

The Medical School Building, completed in 1929, housed all the preclinical classes in one building for the first time. The six-columned portico in the center of the building is a deferential nod to the Rotunda's south portico. The original Old University Hospital is visible in this image, located between the two structures with cupolas. The Corner Building is also shown in its present location to the left of the Medical School Building. (Courtesy of the University of Virginia Alumni Association.)

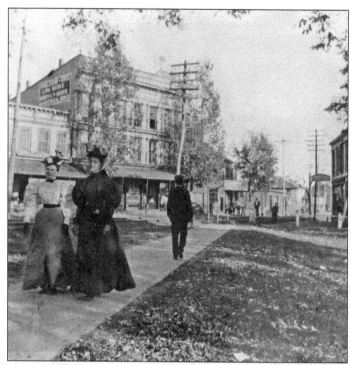

The Anderson Brothers Bookstore had been recently completed when this 1897 photograph was taken. To the left of the bookstore is Carter's Grocery, the site of today's Littlejohn's Deli. The building at the right edge of the photograph is Temperance Hall, which later housed the University Bookstore. This building was demolished in 1914 to make way for the Senff Gates. (Courtesy of Visual History Collection [RG-30/1/10.011], Special Collections, University of Virginia Library.)

As the University expanded in the late 19th century, it became increasingly difficult for trains, pedestrians, and horses and wagons to share the same road leading to the Corner. In 1901, construction of the C&O railroad trestle commenced, which required digging out University Avenue underneath the tracks. Shortly after completion, it became customary to paint baseball and football scores on the sides of the trestle. The brick-paved Main Street ended at the bridge, denoting the Charlottesville and Albemarle County boundary that existed until the city annexed land extending out to Ivy Road in 1916. (Courtesy of Holsinger Collection [MSS 9862], Special Collections, University of Virginia Library.)

In this c. 1900 image, Dr. Paul Barringer is shown in a horse-drawn carriage with Dr. William Randolph at Fifteenth Street on the Corner. Dr. Barringer pressed for the creation of the University of Virginia Hospital, of which he became superintendent in 1901. The wooden buildings in the background characterized the Corner prior to the construction of more substantial brick structures in the early 20th century. (Courtesy of the Albemarle Charlottesville Historical Society.)

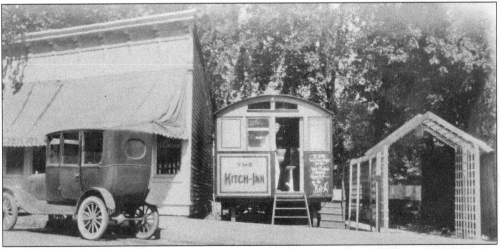

The Kitch-Inn diner was a favorite late-night hangout for students on the Corner. The portable dining car was moved from Rugby Road to the Corner in 1922. Shortly after this picture was taken, a log cabin was constructed around the dining car. Three years later, the owners acquired the structure to the left, which became the Kitch-Inn Annex, another popular eating establishment until the 1940s. The Kitch-Inn and Annex were located in the vicinity of the present-day Trinity restaurant. (Courtesy of Jackson Davis Papers, Accession No. 3072, Special Collections, University of Virginia Library.)

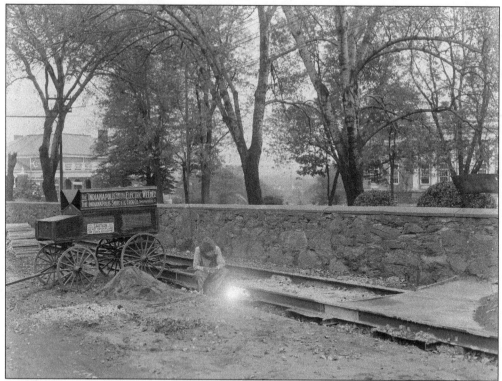

A workman repairs the Charlottesville and Albemarle Railway Company trolley tracks shortly after the fieldstone wall was constructed along University Avenue. (Courtesy of Holsinger Collection [MSS 9862], Special Collections, University of Virginia Library.)

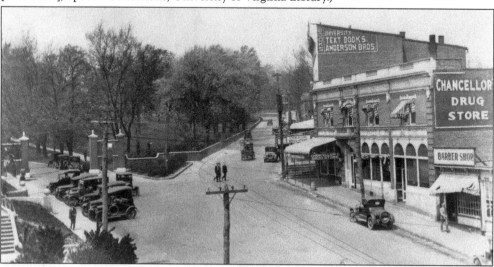

The Chancellor Building and Senff Gates had been constructed on the Corner by 1915. The Chancellor Building housed Chancellor's Drugstore, a billiard hall, and a restaurant on the first floor, and one-room student apartments on the second floor. The Senff Gates were designed by Henry Bacon, architect for the Lincoln Memorial. The building housing the White Spot is currently located in the area shown on the far right. (Courtesy of Visual History Collection [RG-30/1/10.011], Special Collections, University of Virginia Library.)

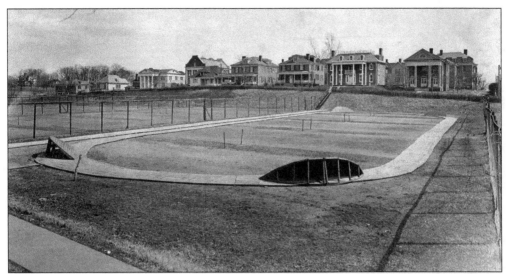

A shortage of student housing at the University and a desire for better accommodations prompted the construction of several fraternity houses along Madison Lane between 1902 and 1928. The Delta Psi house, shown fifth from the right, was the first fraternity house constructed on Madison Lane. The sunken field known as Mad Bowl originally belonged to the YMCA, which was located in Madison Hall until the 1930s. The city's first tennis courts and running track were located here. The University purchased Madison Hall and Mad Bowl in 1971. Mad Bowl is used today for intramural sports. (Courtesy of Visual History Collection [RG-30/1/10.011], Special Collections, University of Virginia Library.)

The Lambeth Colonnade framing Lambeth Field is a Doric order colonnade with a red-tile roof designed by R.E. Lee Taylor and completed in 1913. The field, named after the director of athletics, Dr. William A. Lambeth, served as the University's center for athletic activities until the completion of Scott Stadium in 1931. Houses along University Circle are visible on the far left. (Courtesy of Visual History Collection [RG-30/1/10.011], Special Collections, University of Virginia Library.)

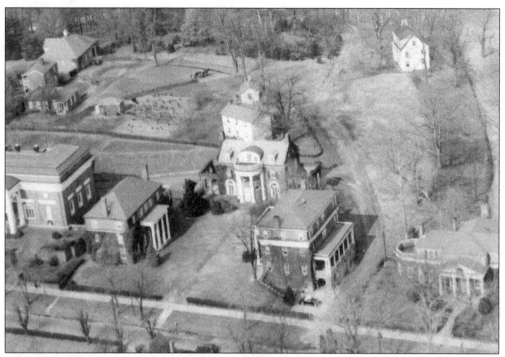

In 1908, the UVa Board of Visitors hired Warren Manning, a landscape architect from Boston, to devise a scheme for the development of university housing on and around Carr's Hill. This marked a new direction for the development of the University, which focused on organized planning as opposed to the ad hoc construction of fraternity houses where space permitted. The Delta Tau Delta fraternity house (currently Sigma Phi) is shown at the head of the three fraternity houses planned around a central courtyard, referred to as "Fraternity Court." The future site of the School of Architecture is located behind these fraternities, and the Bayly Art Museum is visible on the far left. (Courtesy of Albemarle Charlottesville Historical Society, Russell "Rip" Payne Collection.)

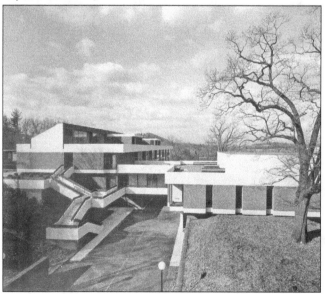

Designed by Pietro Belluschi in collaboration with Kenneth DeMay, this image shows the School of Architecture, including Campbell Hall and the Fiske Kimball Fine Arts Library, in December 1969, shortly before they were completed. Previously, the School of Architecture was housed in Hotel E in the West Range, Fayerweather Hall, and the Bayly Art Museum. The construction of the new building marked the realization of Jefferson's dream to have an architecture school at the University. (Courtesy of Ed Roseberry.)

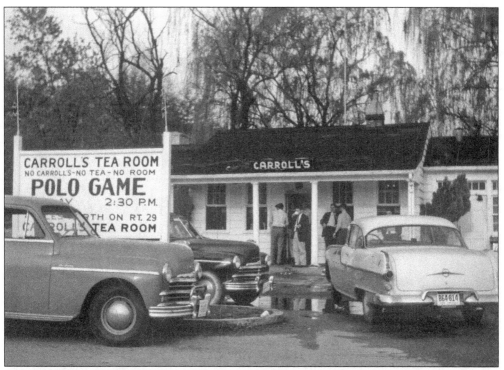

Carroll's Tea Room, located at the southwest corner of Barracks Road and Emmet Street, was the most popular student hangout in the 1950s. Constructed in 1937, far from Grounds down an old dirt road in the country, the sandwich-and-beer restaurant became hugely popular as students returned to the University following World War II. (Courtesy of Ed Roseberry.)

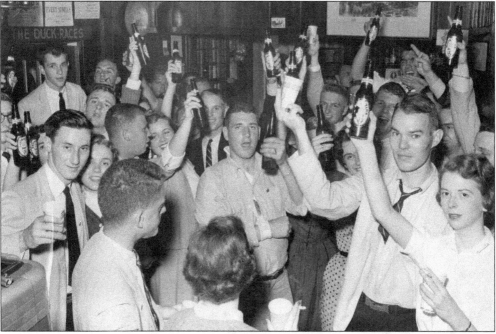

Students enjoy themselves inside Carroll's in the spring of 1956. (Courtesy of Ed Roseberry.)

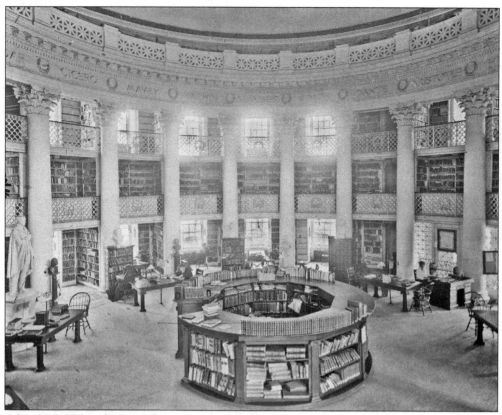

After the 1895 fire, the Rotunda's interior was significantly remodeled by McKim, Mead, and White. As shown in this 1912 view, the architects deviated from Jefferson's original plan by removing the third-floor library and creating a double-height space under the dome. (Courtesy of Holsinger Collection [MSS 9862], Special Collections, University of Virginia Library, Holsinger Collection.)

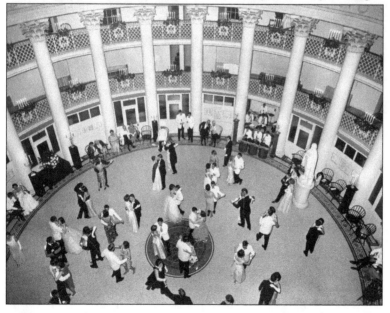

After the completion of Alderman Library in 1938, the Rotunda was used primarily for social and honorific events such as this gala held in the dome room in May 1964. (Courtesy of Ed Roseberry.)

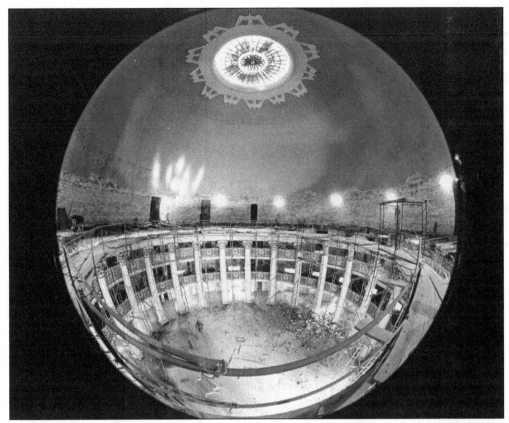

From 1973 to 1976, the McKim, Mead, and White interior of the Rotunda was removed, and the space was returned to a facsimile of the Jefferson-era design, reinserting a third-floor story. In the absence of any detailed drawings of the interior, the architects and architectural historians, including UVa professor of architectural history Frederick D. Nichols, relied on physical evidence and educated guesses concerning plasterwork that might have been original to the building. This image shows the early stage of removal of McKim, Mead, and White's interior. The only element that was retained was Stanford White's dome. (Courtesy of Ed Roseberry.)

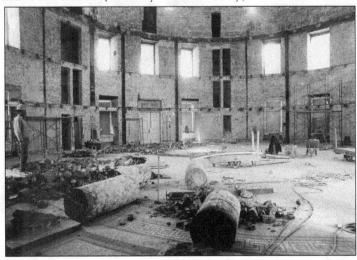

McKim, Mead, and White's interior has been completely removed from the Rotunda in this view. (Courtesy of the University of Virginia Alumni Association.)

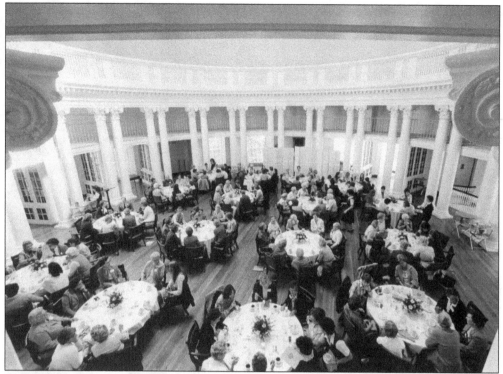

The reconstruction of Jefferson's interior of the Rotunda was completed in 1976. Compare the 40 coupled Composite columns of Jefferson's design to the 20 individual Corinthian columns that McKim, Mead, and White introduced. Also note that the 1970s dome room occupies only the third floor, in contrast to the previous two-story space. The dome room is still used primarily for special events, such as this dinner function held in 1981. (Courtesy of Ed Roseberry.)

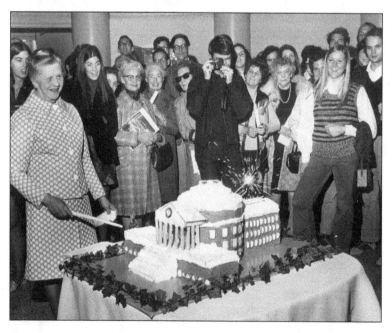

Mary Hall Betts earned the title of "Mama Rotunda" serving as the University's official hostess from 1959 to 1976. Betts is shown here in 1972, having just lit the sparkler that will burn an effigy of the Rotunda and Annex. For a period, the Rotunda Burning Society sponsored annual burnings to commemorate the 1895 fire. (Courtesy of Ed Roseberry.)

Four

CHARLOTTESVILLE'S BUSTLING DOWNTOWN
THE 1920s–1950s

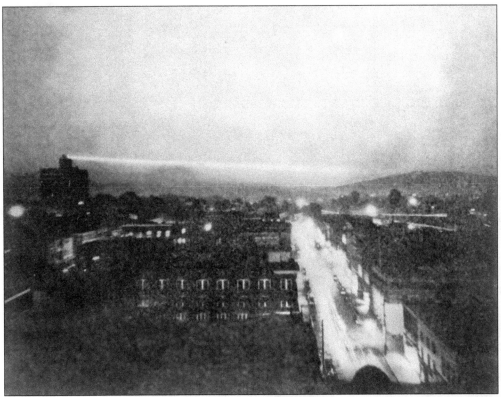

In 1927, an extremely high-powered searchlight (exceeding one billion candlepower) was installed on the roof of the Monticello Hotel. Called the "Thomas Jefferson Beacon" and reported to be visible for hundreds of miles, the light swept the skies between the hotel's namesake and the University during the evening hours. (Courtesy of Visual History Collection [RG-30/1/10.011], Special Collections, University of Virginia Library.)

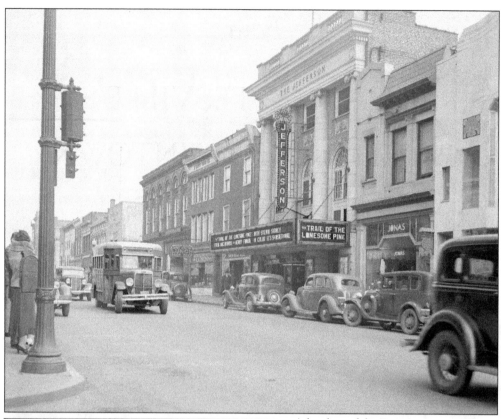

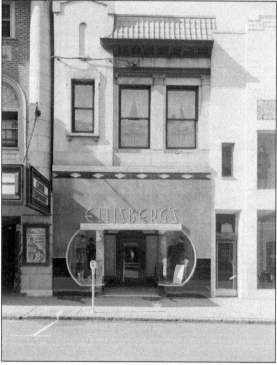

A bus bound for Fry's Spring passes in front of the Jefferson Theater where *The Trail of the Lonesome Pine* starring Henry Fonda and Fred MacMurray was playing in 1936. The Jefferson Theater, established by 1913, showed movies and hosted live acts such as Harry Houdini and the Three Stooges. The Theater was renovated and reopened as a live music venue in 2009. (Courtesy of Visual History Collection [RG-30/1/10.011], Special Collections, University of Virginia Library.)

Ellisberg's, a popular women's clothing store, was located just west of the Jefferson Theater at 106 East Main Street in 1938. This photograph shows the storefront remodeled in the Art Deco style popular in the United States at the time. Compare this storefront to the earlier one in the image above. (Courtesy of Holsinger Collection [MSS 9862], Special Collections, University of Virginia Library.)

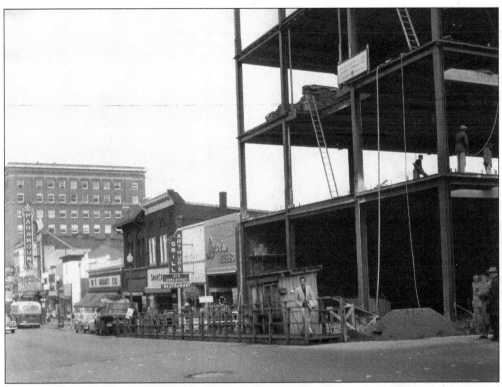

Construction of the six-story Miller and Rhoads department store on the site previously occupied by the Monticello Bank building at the northwest corner of East Main and Fourth Streets was completed in 1956. Miller and Rhoads began in Richmond, Virginia, and became so popular by the 1950s that the company expanded to include stores in Charlottesville, Roanoke, and Lynchburg. (Courtesy of The *Daily Progress*.)

The completed Miller and Rhoads design was considered a modern expression of Jeffersonian architecture with red brick, white trim, round windows, and a serpentine wall on the upper patio where the tearoom was located. Miller and Rhoads closed their downtown location and opened in the Fashion Square Mall in 1981. A large glass area was later added on the Fourth Street side of the building. (Courtesy of Preston Coiner.)

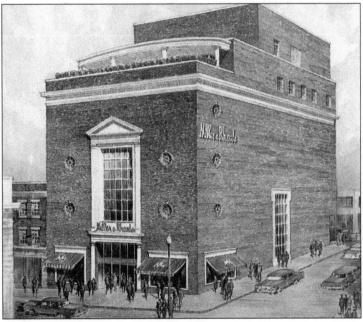

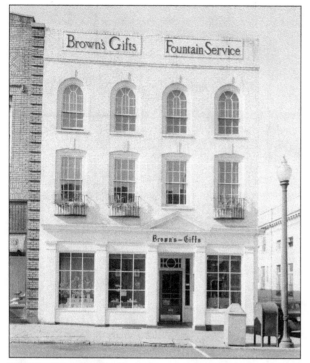

In 1931, Nelson Brown rented a store in the 300 block of East Main Street and opened Brown's Gifts. The following year, a fire destroyed the store, and Brown reopened at the southeast corner of Fourth and Main Streets in the building shown at left. Essentially a department store, the establishment was wildly popular and known for its high-quality merchandise. In 1954, this building was also destroyed by fire. (Left, courtesy of Holsinger Collection [MSS 9862], Special Collections, University of Virginia Library; below, courtesy of the Albemarle Charlottesville Historical Society.)

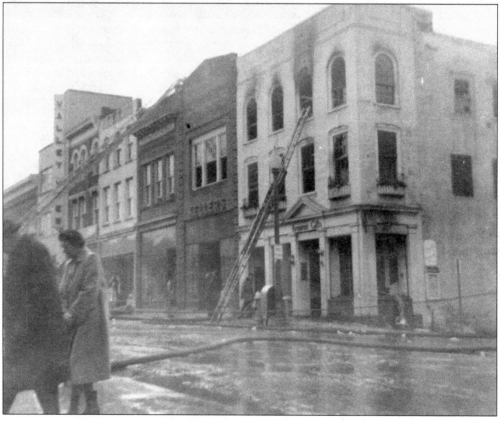

The Lafayette Theater opened in 1921 on the south side of West Main Street between First and Second Streets. Reportedly named after Thomas Jefferson's friend, the Marquis de Lafayette, the theater was deemed a modern marvel when it opened in 1921. This photograph shows the cinema around 1940 after its popularity began to wane. The large three-story building with the cast-iron storefront to the left of the theater was the Perley Building, which housed a furniture store and undertaking business founded by James Perley in the 1880s. Today, the site is occupied by the Terraces. (Courtesy of Albemarle Charlottesville Historical Society, Russell "Rip" Payne Collection.)

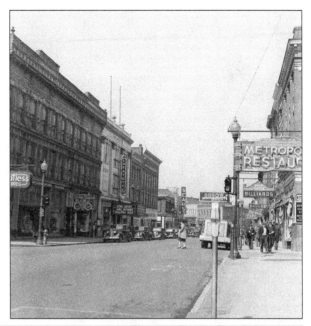

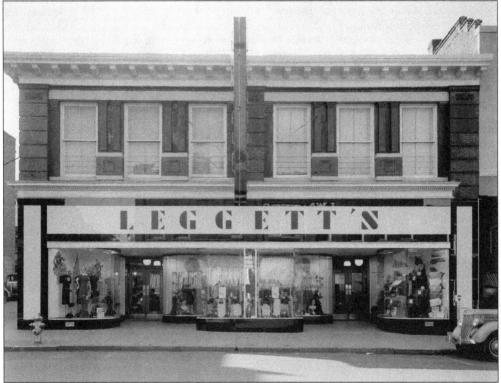

Leggett's department store, shown here with its original Art Deco facade, opened in 1938 on West Main Street just west of Second Street. Department stores thrived on Main Street during this period. In addition to Leggett's, F.W. Woolworth's, McCrory's, and W.T. Grant's were also located downtown. Leggett's expanded in 1939 and again in 1951. (Courtesy of Holsinger Collection [MSS 9862], Special Collections, University of Virginia Library.)

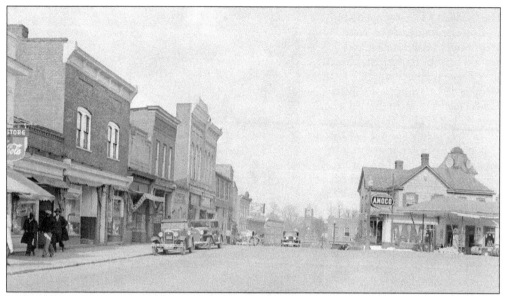

In the 1920s, the view from the intersection of West Main and Ridge Streets (the location of today's Lewis and Clark monument) was open all the way to the bell tower of the First Baptist Church near Lee Park. At that time, there was a continuous stretch of commercial buildings from West Main Street downhill to East Main Street. Today's Lewis and Clark Square condominiums occupy the site of the gas station shown on the right. (Courtesy of Visual History Collection [RG-30/1/10.011], Special Collections, University of Virginia Library.)

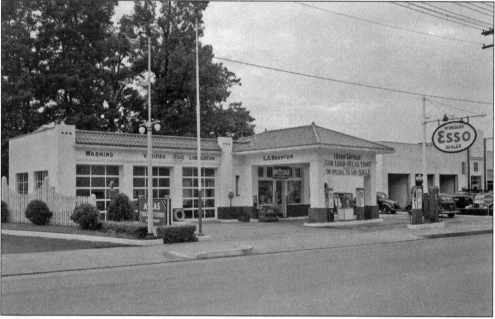

The Brunton Service Station was located at 850 West Main Street, a short distance west of Union Station. By mid-century, businesses catering to the automobile, such as filling stations and car repair shops, proliferated along West Main Street. Charlottesville Motors was located just to the west (right). A parking lot now occupies this site. (Courtesy of Holsinger Collection [MSS 9862], Special Collections, University of Virginia Library.)

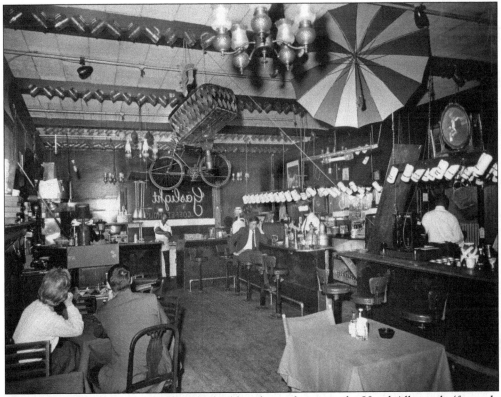

The Gaslight Restaurant opened in the building located next to the Hotel Albemarle (formerly the Gleason Hotel) at West Main and Sixth Streets in 1963. The eclectic interior attracted both students and locals. (Courtesy of Ed Roseberry.)

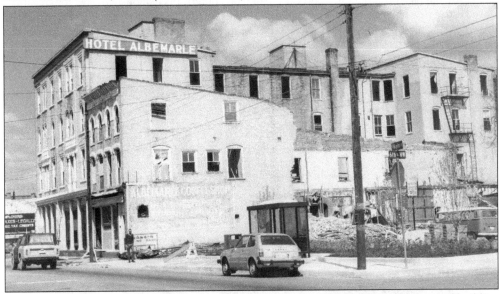

In 1972, the Gaslight restaurant moved to Emmett Street. In 1980, the former restaurant building was demolished. The hotel has since been converted to commercial and office space, and a parking lot occupies the former Gaslight site. (Courtesy of Albemarle Charlottesville Historical Society.)

In 1898, Charlottesville's Presbyterians constructed a church behind the National Bank building at Market and Second Streets. The eclectic American Renaissance church drew from many different styles, including Romanesque Revival, evident in the heavy massing and crenellated tower. Gothic Revival elements are also present in the pointed arch windows and tracery. After a 1955 fire damaged the building beyond repair, the church was demolished, the congregation moved into a new building on Park Street, and the church changed its name to First Presbyterian. Today, a parking lot is located on the site of the former church. (Courtesy of the Albemarle Charlottesville Historical Society.)

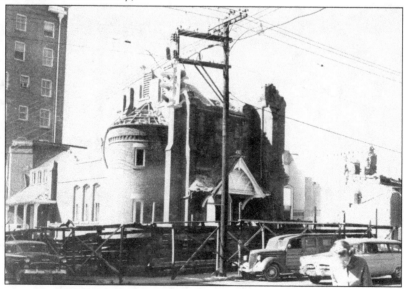

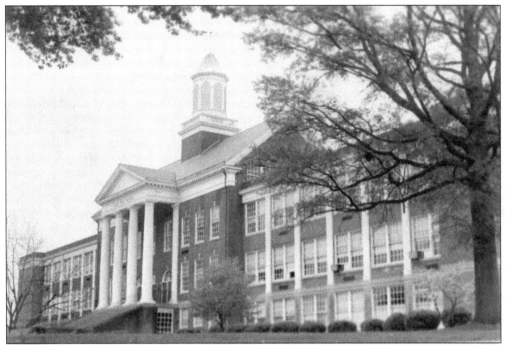

A new high school for white students was built on Preston Avenue in 1939 when the student population outgrew the Midway School building. Midway was renamed Lane High School in 1924 for the Midway principal and school superintendent, James W. Lane, and the name was transferred to the new school. The new Lane High School was the stage of several significant events during Charlottesville's tumultuous period of integration. Lane closed when Charlottesville High School was built on Melbourne Road in 1974. Albemarle County purchased the building and renovated it for county offices, which opened in 1981. (Courtesy of Albemarle Charlottesville Historical Society, Allaville Magruder Collection.)

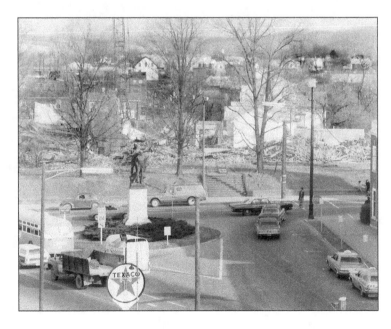

After Midway closed as a school, the building was used for city offices until 1966. Following years of gradual deterioration, Midway was demolished in 1973. The Midway Manor senior housing complex was built on the site in 1977. (Courtesy of Ed Roseberry.)

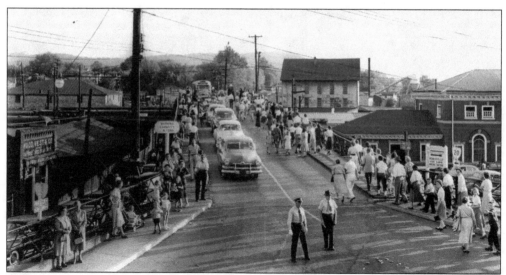

In 1891, the Belmont Land Company bought 551 acres south of town that had been part of a 2,500-acre 18th-century estate. The city began annexing the area in 1888. Additional annexations in 1916 and 1939 brought most of Belmont into the city limits. Belmont's location was convenient for businesses established on the south side of town, including the C&O railroad and station (visible on the right) and the Charlottesville Lumber Company. This 1951 photograph shows spectators returning home by way of the old Belmont Bridge after the Apple Harvest Festival parade. This original Belmont Bridge was a two-lane steel bridge built over the railroad tracks in 1905, construction of which helped spur development of the neighborhood. (Courtesy of Ed Roseberry.)

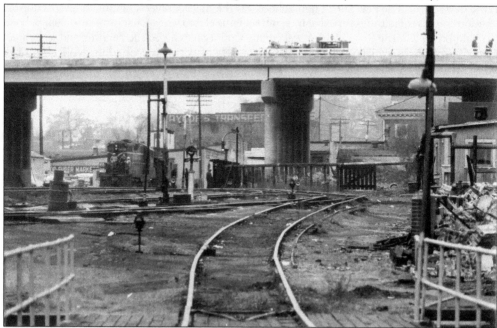

A new four-lane Belmont Bridge was approved by Charlottesville City Council in 1957. This view, facing west from what is today the east end of Water Street, shows the bridge nearly complete in 1960. A corner of the C&O station is visible under the bridge to the right. (Courtesy of the Albemarle Charlottesville Historical Society, Russell "Rip" Payne Collection.)

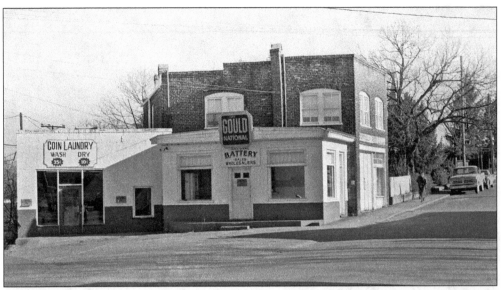

The close-knit Belmont neighborhood developed its own commercial area, centered around Hinton Avenue and Monticello Road. By the mid-20th century, a gas station, an automobile repair shop, and other general services were located in the area. This photograph shows a laundromat and battery shop at the intersection of Monticello Road and Hinton and Carlton Avenues in the mid-1970s. These buildings are currently occupied by Mas restaurant and Ashatanga Yoga Charlottesville. (Courtesy of John Shepherd.)

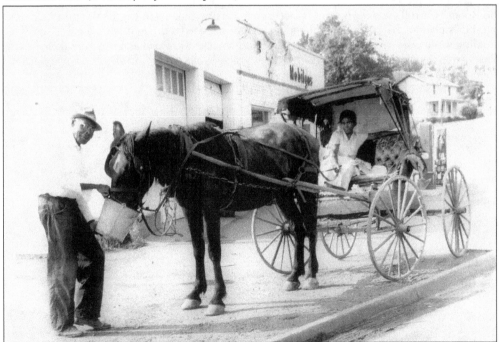

Despite the proliferation of the automobile in the first half of the 20th century, this c. 1960 image shows lingering vestiges of an earlier way of life. This family regularly traveled into Charlottesville from Palmyra on a horse and buggy, and they are pictured here at the outskirts of Belmont, heading home. (Courtesy of Ed Roseberry.)

Carroll's Tea Room was constructed in 1937 as a gas station at the southwest corner of Barracks Road and Route 29 North. In 1939, it was converted to Spencer's Tea Room, until Carroll Walton purchased the property in 1945 and changed the name. His slogan was, "No Carroll, No Tea, No Room." Carroll's was *the* meeting place for University students in the 1940s and 1950s. The late-1950s plan for Barracks Road Shopping Center included a drive-in bank for this site. The building was moved up Route 29 North to a location near Rio Road and was later demolished. The Tavern restaurant, which opened in 1952, is visible to the left of Carroll's in the image below. (Courtesy of Ed Roseberry.)

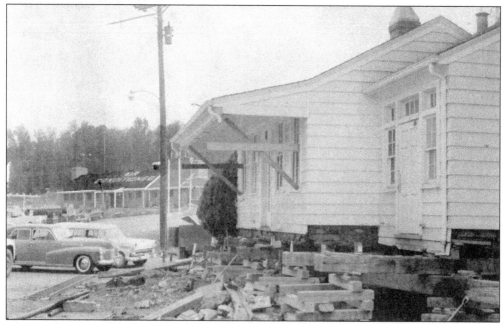

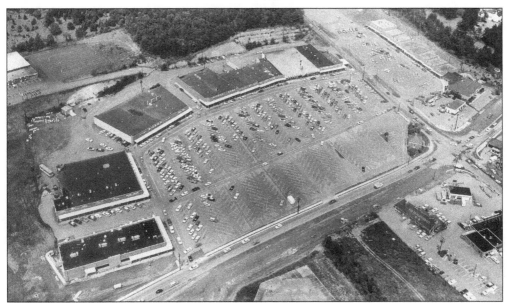

In October 1959, Barracks Road Shopping Center, shown in the image above, celebrated its grand opening with 21 stores open for business. In response to Charlottesville's growing dependence on the automobile, the center advertised acres of free parking. The image below shows a K-Mart store under construction at Route 29 North and Hydraulic Road in 1964. These photographs illustrate the rise and later dominance of the large retail stores and strip malls built on the outskirts of Charlottesville in response to suburbanization in the 1950s and 1960s. The popularity of Barracks Road Shopping Center and other chain department stores facilitated the decline of Charlottesville's downtown and Main Street. The Ridge Drive-in movie theater, which closed in the early 1970s, is visible in the lower-left corner of the image below. The Sperry Piedmont Company, which moved to Charlottesville in 1956, is also visible in the top left of the lower image. (Above, courtesy of Ed Roseberry; below, courtesy of the Albemarle Charlottesville Historical Society, Russell "Rip" Payne Collection.)

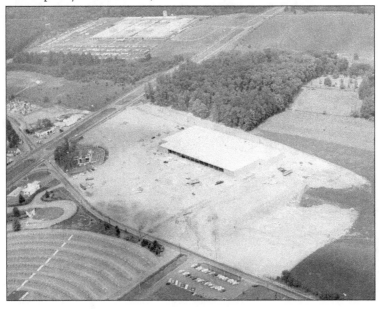

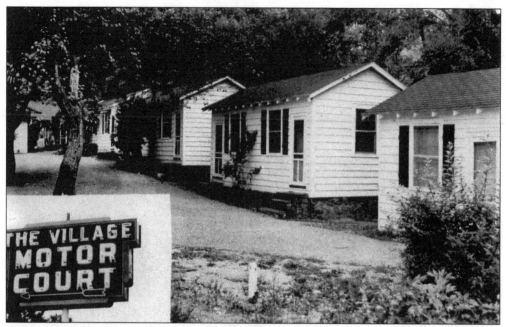

Hotels and motels proliferated along the nation's highways in response to the rise of the automobile. Designed as a series of individual rustic cottages situated relatively close to Grounds, the Village Motor Court was located at the intersection of Route 29 North and Route 250 West in the early 1950s. The Cavalier Inn is currently located at this site. (Courtesy of Preston Coiner.)

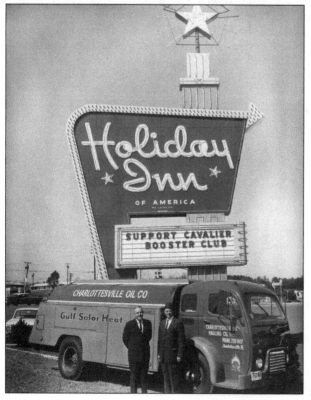

The Holiday Inn chain, founded in 1952, came to Charlottesville in 1963. The inn was constructed on the east side of Route 29 North at the Route 250 Bypass intersection. A classic roadside sign, the "Great Sign" was the company's standard from the 1950s through the 1970s and illustrates the shift from mom-and-pop-owned motor courts to nationwide chains. Gulf service stations were established at many Holiday Inns, and Gulf credit cards were accepted for lodging and food at the inn. In Charlottesville, Gulf was a strong sponsor of the University's athletic club. The "Great Sign" no longer stands; the site is now occupied by the Day's Inn. (Courtesy of Ed Roseberry.)

Five

CHANGING PERCEPTIONS AND SHIFTING BOUNDARIES
CHARLOTTESVILLE IN THE 1960S AND 1970S

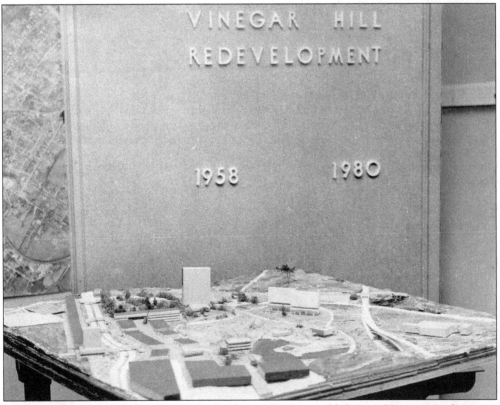

In 1954, Charlottesville City Council passed a resolution establishing a Housing Authority to address substandard housing—in particular, the predominantly African American Vinegar Hill neighborhood, one of Charlottesville's oldest, located immediately west of downtown. In 1960, as part of the now-much-maligned urban renewal movement, a referendum to redevelop Vinegar Hill passed by a narrow margin. This model of the 1958 proposal for redevelopment shows new high-rise commercial and office buildings. Very little shown in this model came to fruition, except the demolition of Vinegar Hill. (Courtesy of the Albemarle Charlottesville Historical Society, Russell "Rip" Payne Collection.)

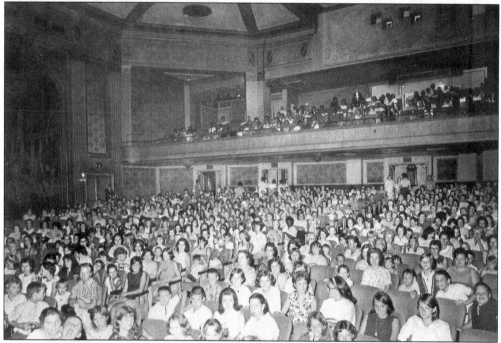

Segregated conditions persisted in Charlottesville nearly 100 years after the issuance of the 1863 Emancipation Proclamation, as illustrated in this c. 1960 photograph taken inside the Paramount Theater. African Americans were required to sit in the theater balcony and enter the building from a separate side entrance. (Courtesy of the Albemarle Charlottesville Historical Society, Russell "Rip" Payne Collection.)

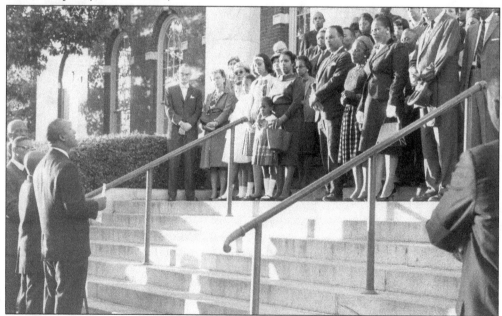

Civil rights demonstrators marched peacefully along Market Street in the late 1950s. Their march ended on the steps of the Federal Courthouse and Post Office Building, today's public library. (Courtesy of the Albemarle Charlottesville Historical Society, Russell "Rip" Payne Collection.)

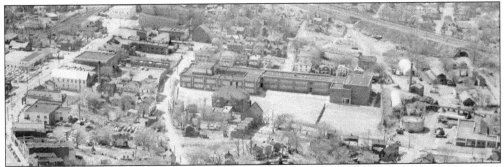

The original portion of the Jefferson School, the far-left wing of the long structure in the center of the photograph, was completed in 1926. The school was one of the first high schools constructed for African Americans in the state of Virginia. Prior to its opening, African American students could attend the Jefferson Graded School—shown in this image in front of the high school—only through the eighth grade. In order to attend high school, they had to go outside the city and county. (Courtesy of the Charlottesville Redevelopment Housing Authority.)

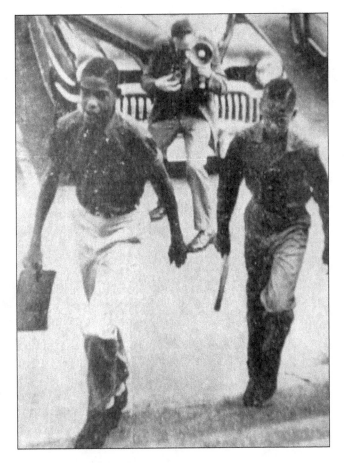

On September 8, 1959, John and Donald Martin enter the previously all-white Lane High School after desegregation. In 1958, four years after the *Brown v. Board of Education* Supreme Court decision, the governor of Virginia ordered the all-white Lane High School and Venable Elementary School to close their doors rather than integrate. Black and white students received separate instruction from teachers in local churches, businesses, and private residences that year. Under mounting pressure, the two schools reopened in 1959. (Courtesy of the *Daily Progress*.)

School integration and the redevelopment of Vinegar Hill were deeply intertwined issues in Charlottesville in the 1950s and 1960s. The 1960 redevelopment referendum entailed razing the 20-acre Vinegar Hill site and relocating residents to a nearby low-income housing development. Although some houses were dilapidated and not connected to plumbing or electricity, this image shows that many homes and businesses demolished for the redevelopment were well maintained and structurally sound. (Courtesy of the Charlottesville Redevelopment Housing Authority.)

Some of the residences in Vinegar Hill, however, were severely deteriorated. The houses pictured here were among those demolished during redevelopment. (Courtesy of the Charlottesville Redevelopment Housing Authority.)

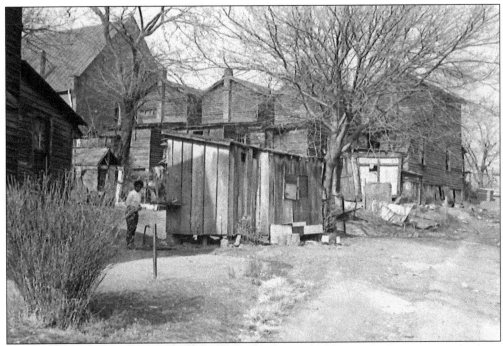

A Vinegar Hill resident stands in front of an outhouse and gets water from a pump behind the dense residential area behind Zion Union Baptist Church, visible in the left background. The church served the Vinegar Hill community from 1895 until 1965, when its building was demolished and its congregation forced to relocate. The Staples parking lot is currently located on the site. (Courtesy of the Charlottesville Redevelopment Housing Authority.)

The Hook, Hose, and Ladder Company, Charlottesville's fire department, was located in this turn-of-the-century building at Water and West Main Streets until 1960. It was razed as part of the Vinegar Hill redevelopment. The Lewis and Clark Square condominiums now stand just west of the site. (Courtesy of the Albemarle Charlottesville Historical Society.)

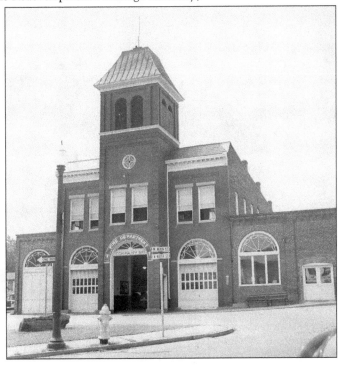

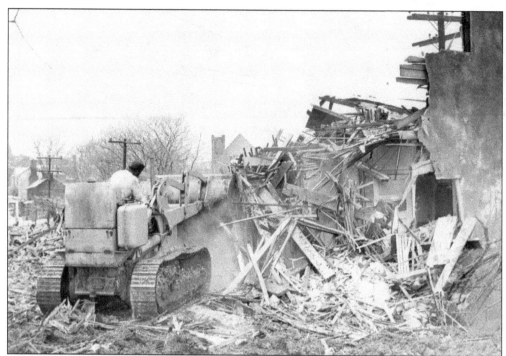

Housing in the area of Third Street NW was demolished as part of the redevelopment. Note the roof and tower of Zion Union Baptist Church visible in the center background. (Courtesy of the Albemarle Charlottesville Historical Society, Russell "Rip" Payne Collection.)

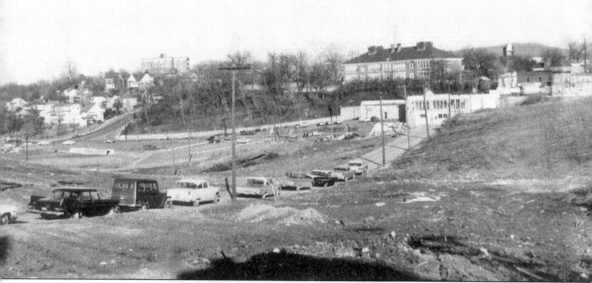

By 1965, the demolition of 158 residences and 29 businesses was nearly complete, as seen from this point near the Zion Union Church site. Commerce Street, which once bisected the site and connected with Preston Avenue, is shown on the far left with parked cars. McGuffey School is visible in the center left, and the bell tower of First Baptist Church is visible in the

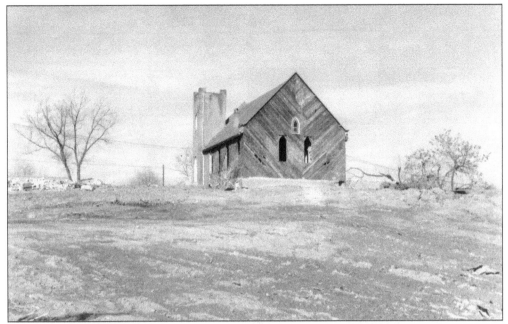

Construction of the Zion Union Baptist Church began in 1902 and lasted 17 years. It was one of the last buildings to be demolished in Vinegar Hill. The original wooden structure underneath the later brick veneer is visible in this image. The congregation eventually relocated to Preston Avenue and constructed a new church designed by local architect Milton Grigg. (Courtesy of the Albemarle Charlottesville Historical Society.)

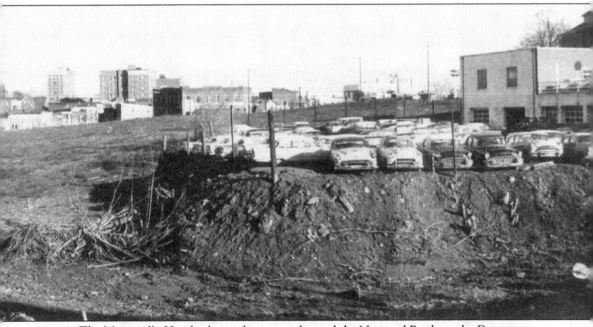

center. The Monticello Hotel is located center right, and the National Bank on the Downtown Mall is to the right of the hotel. The Oldsmobile dealership and parking lot on West Main Street, currently a furniture store, are visible on the far right. (Courtesy of the Albemarle Charlottesville Historical Society.)

The commercial corridor on the north side of West Main Street extending from the Lewis and Clark statue to Preston Avenue was demolished as part of the redevelopment. These views, taken from approximately the same location, show the significant impact of the project on Charlottesville's urban landscape. Note the Oldsmobile building in the image below. Its corner is just behind the Lewis and Clark statue in the image above and in the top image on the next page. (Above, courtesy of the Charlottesville Redevelopment Housing Authority; below, courtesy of Ed Roseberry.)

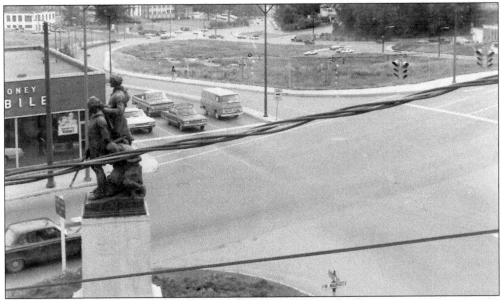

The Ridge/McIntire connector was constructed through the redevelopment area just beyond the Oldsmobile building. This area was dubbed the Central City Plaza, and its development was touted as the solution to the economic decline of Charlottesville's downtown. The connector was intended to facilitate traffic flow into downtown, but the ultimate road plan was never realized. The Federal Building, completed in 1983, is currently located in the portion of the grassy island closest to Main Street. (Courtesy of the Charlottesville Redevelopment Housing Authority.)

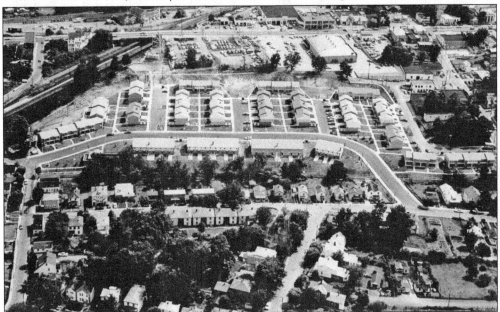

A majority of the 600 residents displaced by the redevelopment were relocated to Westhaven. The 225-unit public-housing project was constructed north of West Main Street, following demolition of a residential area that included Cox's Row. Westhaven was named for John West, a former slave who became a large landowner in the area. (Courtesy of the Charlottesville Redevelopment Housing Authority.)

The commercial corridor progressing up West Main Street along Vinegar Hill is shown in the image above. The image below, taken from the same vantage point, shows the view after demolition. Note Jefferson High School in the distance. The white brick Victory Shoe Store building currently houses a yogurt shop and a salon. The Ritter Finance Loan building currently houses Reflections Salon. The Kane Furniture store, now located farther west on West Main Street, appears at the far left in the image above. (Both, courtesy of the Charlottesville Redevelopment Housing Authority.)

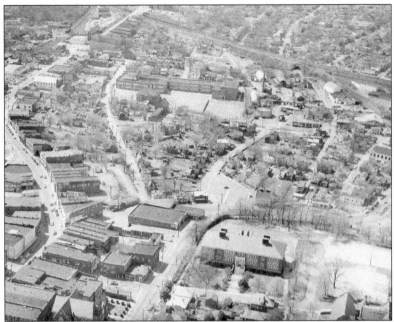

Vinegar Hill, as shown in these photographs before and after demolition, occupied a triangular area bounded by West Main Street, Preston Avenue, and Fourth Street NW. Large portions of the redevelopment area remained undeveloped well into the 1980s, nearly 20 years after demolition. Businesses and fast food chains now occupy the area, including Staples, the Omni Hotel, Wendy's, and McDonald's. McGuffey School is visible in the foreground, and Jefferson School is visible in the background of both images. Note in the lower image, the five-story Brutalist-style Citizens Commonwealth Building, visible in the center right, which was the first building erected after demolition, in 1970. (Above, courtesy of the Charlottesville Redevelopment Housing Authority; below, courtesy of the Albemarle Charlottesville Historical Society, Russell "Rip" Payne Collection.)

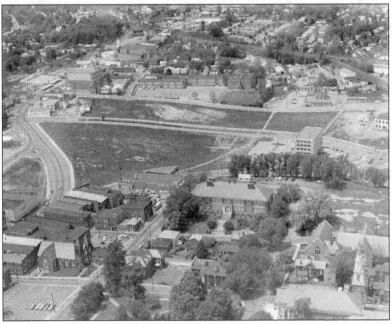

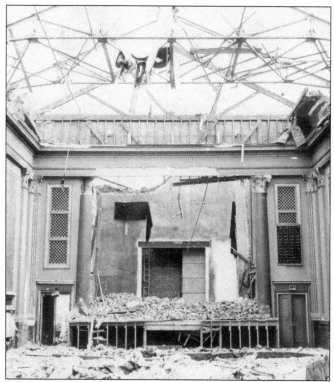

Vinegar Hill was not the only area of Charlottesville to undergo significant changes during the tumultuous decades of the 1960s and 1970s. The Lafayette, sometimes referred to as the "Horse Opera" because it showed so many Westerns, began to decline with the rising popularity of the television and the opening of the Paramount Theater in 1931 and the University Theater in 1937. The Lafayette closed in 1959, and the building was demolished the following year. Roses department store was constructed in its place and the York Place Shops now stand in this location. (Courtesy of the Albemarle Charlottesville Historical Society, Russell "Rip" Payne Collection.)

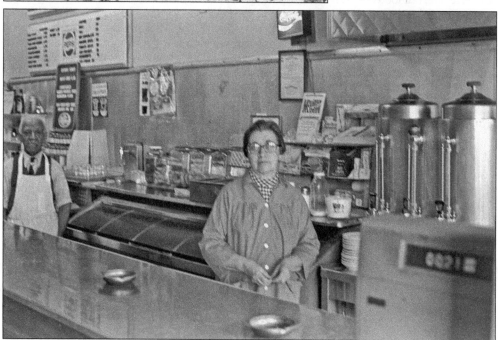

Although Charlottesville's urban landscape was changing, some businesses persevered. Owner Katy Chiknas and longtime employee Jack Bowling stand behind the counter at Virginia Lunch on East Main Street, around 1972. Today, the Mudhouse coffee shop occupies this building. (Courtesy of John Shepherd.)

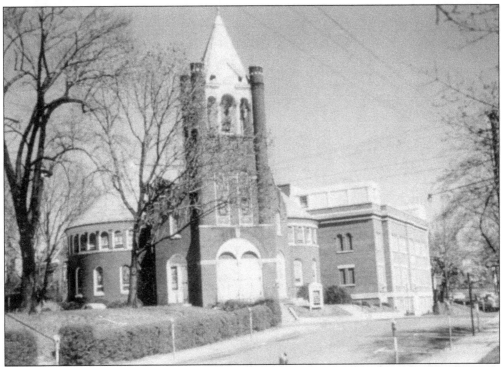

The First Baptist Church was constructed in 1904 after a fire razed the previous church on the site. The new church was a red brick Romanesque Revival structure located off the northeast corner of what would become Lee Park. The interior of the church was noted for its magnificent pendentive dome set over a semicircular nave. The church was destroyed by fire in 1977, and the Queen Charlotte Square condominiums now occupy the site. (Above, courtesy of the Albemarle Charlottesville Historical Society; below, courtesy of Jim Carpenter.)

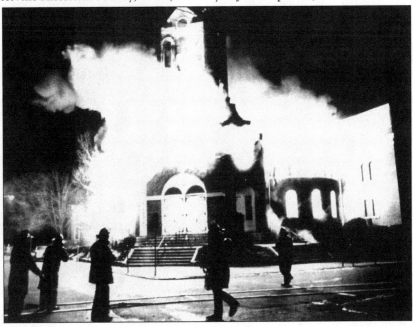

Protests and demonstrations were a common occurrence at the University throughout the 1960s and 1970s. Students protested in favor of civil rights, integration, and women's rights, and against apartheid and the Vietnam War. This image shows students participating in the "Nashville, Tennessee-to-Washington, D.C. Walk for Peace" in April 1962, which combined the civil rights and peace movements. (Courtesy of Ed Roseberry.)

A student, one of about 30 protesters, burns his draft card in front of the University of Virginia Chapel in 1970. After burning 13 draft cards, the protestors marched to the draft board and presented the ashes to the clerks. (Courtesy of Jim Carpenter.)

Women had been on University Grounds as early as the 19th century attending summer schools and nursing programs, but since 1920, they had only been allowed to attend the University's graduate and professional schools. In 1969, after suing the University for gender discrimination, four females were admitted to the University for the first time as undergraduates in the College of Arts and Sciences. The following year, 450 women were admitted, and 550 entered in 1971. Open admissions began in 1972. By 1974, women made up 43 percent of the entering class. As the number of female undergraduate students soared in the 1970s, the cultural and social life of the University changed significantly. (Courtesy of Ed Roseberry.)

In the midst of urban renewal, the civil rights movement, integration, antiwar protests, and demolitions in a rapidly changing Charlottesville, these local men take refuge at the men-only Brass Rail billiard parlor in the 100 block of West Main Street around 1972. (Courtesy of John Shepherd.)

In 1935, the denial of Alice Jackson's admission to the University because of her race initiated a law that allowed African Americans to apply for funding to attend out-of-state schools. Although this law remained in place until 1968, the University admitted Gregory Swanson, an attorney and the first African American to attend the University, in 1950. (Courtesy of Visual History Collection [RG-30/1/10.011], Special Collections, University of Virginia Library.)

Elected in 1970, Charles Barbour was the first African American to sit on Charlottesville City Council. Barbour became mayor in 1972 and focused his efforts on the revitalization of downtown. Along with his fellow Charlottesville City Council members—including Jill Rinehart, the first female member of Charlottesville City Council—he supported the controversial process of constructing the Downtown Mall. (Courtesy of Visual History Collection [RG-30/1/10.011], Special Collections, University of Virginia Library.)

Six

Downtown Transforms
The Creation of a
Pedestrian Mall

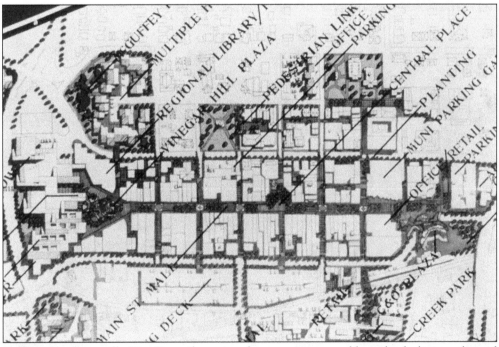

In 1971, Charlottesville City Council appointed a commission to address the declining sales and property assessments in downtown Charlottesville. The prominent landscape architecture firm, Lawrence Halprin and Associates, was commissioned to design a master plan. This 1974 plan proposed a pedestrian mall along East Main Street that extended down each of the side streets. A farmers' market area was planned in the C&O Plaza on the far right, and a library and the Vinegar Hill Plaza were proposed at the opposite end of the mall. This original plan showed the Central Place Plaza in the center of the mall, but the location was changed when a fire razed nearly half a block of buildings. (Courtesy of the Lawrence Halprin Collection, The Architectural Archives, University of Pennsylvania.)

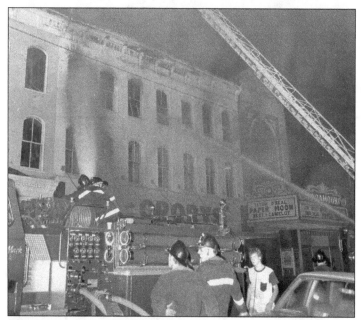

Firefighters stopped the fire that burned the McCrory's store and the adjacent building before it spread to the Paramount Theater, but the two retail buildings could not be saved and were demolished. The resulting open space prompted the relocation of Central Place Plaza to this site instead of the original, more central, location shown on Halprin's master plan. (Courtesy of the Albemarle Charlottesville Historical Society, Russell "Rip" Payne Collection.)

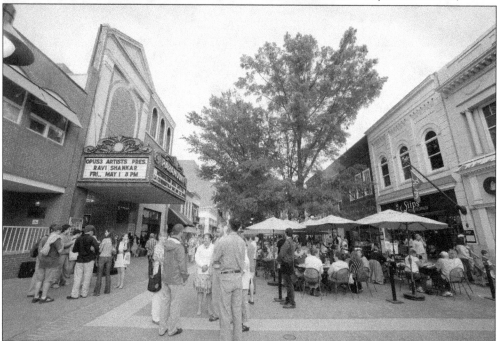

The Paramount Theater, designed by the Chicago architecture firm Rapp and Rapp, opened in 1931. The 1973 fire that burned the adjacent buildings also damaged the theater. With the opening of the Terrace Theater next to K-mart, the Paramount Theater closed in 1974. The theater escaped the wrecking ball in the 1970s and again in the 1980s, and was purchased by the Paramount Theater Inc. nonprofit organization in 1992. A city grant funded the initial restoration of the marquee. In 2002, restoration of the theater began under the direction of Martinez + Johnson Architecture and a local firm, Bushman Dreyfus Architects. The restored theater reopened in 2004 and now presents a wide range of entertainment and educational events. (Courtesy of Jack Looney.)

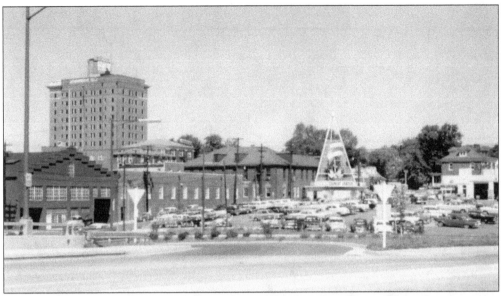

The step-gabled building at the far left once housed the City Sign Shop and later the city garage. It was razed to make way for the construction of the new Charlottesville City Hall, designed by local architect Milton Grigg, in the late 1960s. The pyramidal structure, also designed by Grigg, was a temporary tourist information center located in the municipal parking lot at East Market and Seventh Streets, constructed for Charlottesville's bicentennial celebration in 1962. The triangular panels were painted with historic figures and lit with floodlights. (Courtesy of Ed Roseberry.)

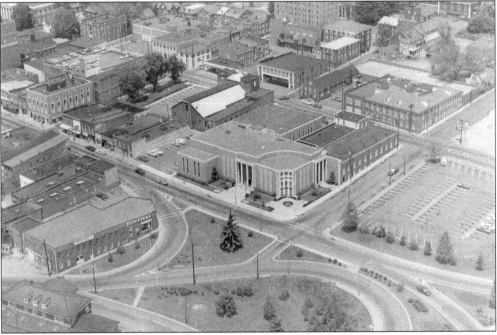

The new Charlottesville City Hall building, constructed at the east end of East Main Street, opened in 1969. The modernist building has a cutaway southeast corner featuring a monument to Jefferson, Madison, and Monroe, three of the nation's founding fathers from the local area. (Courtesy of the Albemarle Charlottesville Historical Society, Russell "Rip" Payne Collection.)

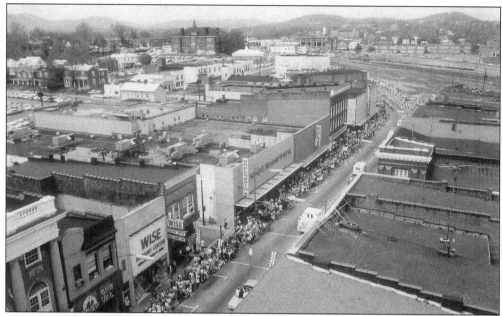

Spectators on East Main Street await the 1970 Dogwood Festival parade, shown marching past the demolished Vinegar Hill site. Neither the pedestrian mall nor the Omni Hotel has been constructed. The Jefferson Theater is visible in the left corner, and today's Terraces and York Place Shops buildings are located where Woolworth's and Roses stores are seen. The Regal Cinema is now located where Leggett's, visible at the end of the street, once stood. The old Midway School building is visible at the top left. (Courtesy of Ed Roseberry.)

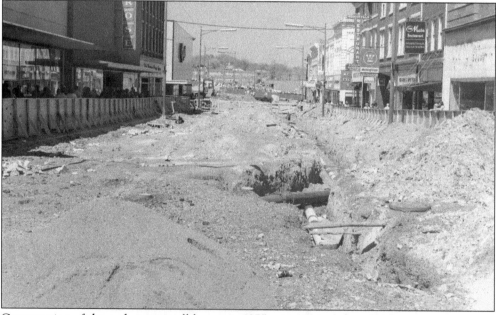

Construction of the pedestrian mall began in 1975 using 11-inch-long bricks set on a concrete bed and mortared. Eventually, the construction of the Omni Hotel at the western end of the mall would block the view of Jefferson School, which is still visible in the distance in this photograph. (Courtesy of the Albemarle Charlottesville Historical Society, Frank Hartman Collection.)

The first five blocks of the mall were complete by 1976. The Nook restaurant is visible behind the truck, and one of the tree wells is shown in the foreground. (Courtesy of the Albemarle Charlottesville Historical Society.)

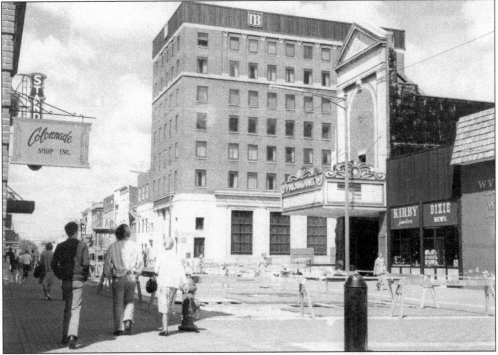

Brick paving is nearly complete, but the willow oaks have not yet been planted. The National Bank building (now Wachovia Bank) and the Paramount Theater and marquee are both shown before restoration. (Courtesy of the Albemarle Charlottesville Historical Society.)

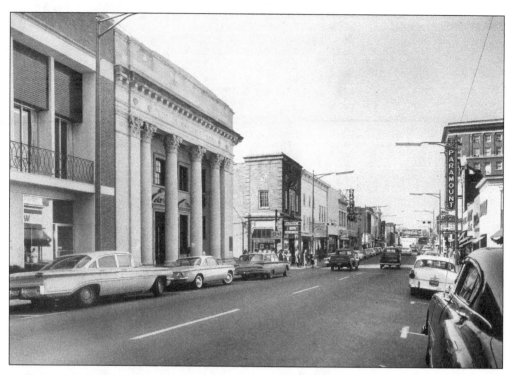

Beginning with the 1976 opening of the Hardware Store, open-air dining, window shopping, and outdoor vending gained popularity and helped transform the mall. These images show East Main Street from the middle of the 300 block facing west before construction and after the mall emerged as a favorite gathering spot. (Above, courtesy of Ed Roseberry; below, courtesy of Jack Looney.)

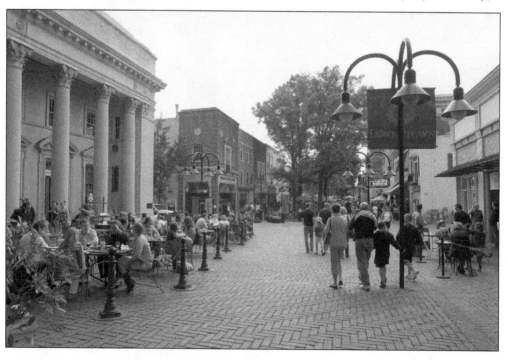

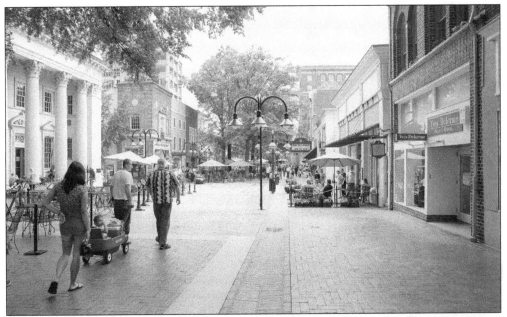

The mall underwent a controversial $7.5 million re-bricking in 2009. Some of Halprin's original design elements were changed. For example, tree grates were installed where Halprin intended the brick floor to extend to the base of the trees. However, other elements that were initially abandoned because of cost, such as the granite banding, were reintroduced. Compare the paving seen here to the previous photograph. (Courtesy of Jack Looney.)

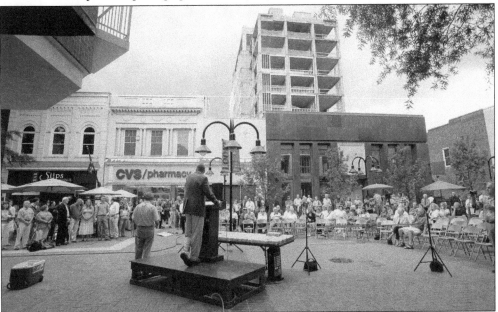

Charlottesville mayor Dave Norris and former chair of the Albemarle County Board of Supervisors, David Slutzky (left), are shown addressing a crowd gathered in Central Place Plaza for the 30th anniversary and rededication ceremony of the Downtown Mall. Construction on the Landmark Hotel (background) halted in the spring of 2009 and the building remains unfinished today. (Courtesy of Jack Looney.)

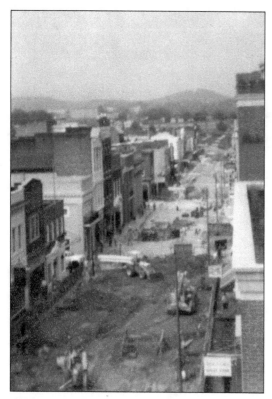

From the rooftop of the parking garage next to Charlottesville City Hall, the scale of the project and transformation of the urban space is unmistakable in these before-and-after images. A total of 63 trees were planted in two phases, as shown in the image below. An additional 31 trees were planted when the mall was extended one block west to the Omni Hotel, not yet constructed in these images. (Both, courtesy of the Albemarle Charlottesville Historical Society.)

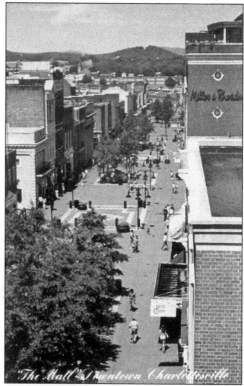

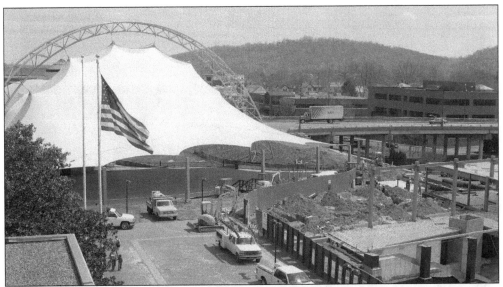

The Charlottesville Pavilion was constructed at the east end of the mall in front of the Belmont Bridge in July 2005. It was built as a more permanent structure in the area where Fridays After Five bands played on a small wooden stage from 1995 to 2004. In addition to Fridays After Five, local, national, and international music acts play at Charlottesville's premier outdoor theater. US president Barack Obama addressed a crowd of nearly 5,000 people at the Pavilion on October 29, 2010. Charlottesville's new transportation center is shown under construction on the right. (Courtesy of Jack Looney.)

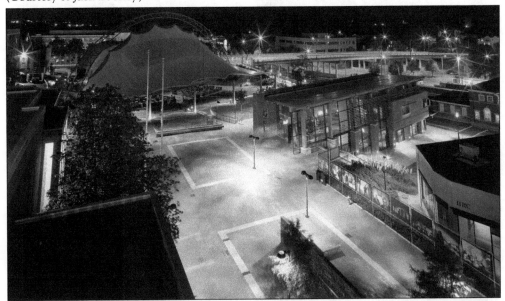

Charlottesville's Transit Center was designed by Wallace, Roberts, & Todd using sustainable design strategies. It was awarded the Leadership in Energy and Environmental Design for New Construction (LEED-NC) Gold certification by The US Green Building Council in 2008. The building was the first in Charlottesville to receive LEED certification. This image captures the Pavilion and its surroundings at night. The roof of Charlottesville City Hall is visible on the left, and the Belmont Bridge is visible in the background on the right. (Courtesy of Jack Looney.)

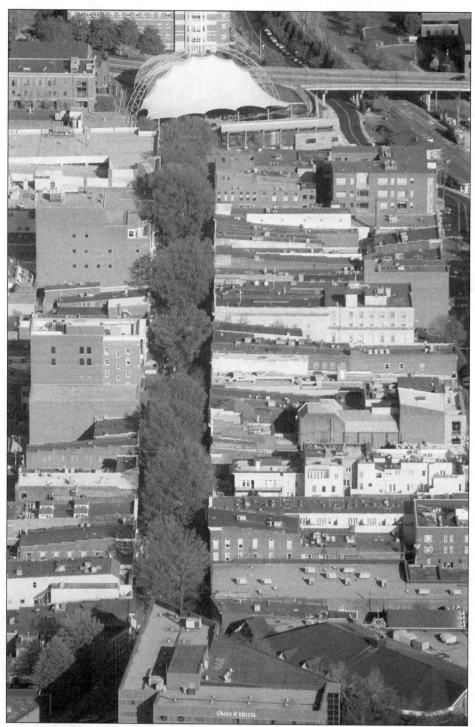

The Omni Hotel and Charlottesville Pavilion frame the west and east ends of the Downtown Mall. The willow oaks, roughly 50 feet high, provide shade for shoppers and diners and cool the temperature of the surrounding dense urban environment by approximately 10 degrees during the hot summer months. (Courtesy of Jack Looney.)

Seven

CHARLOTTESVILLE CELEBRATES
PARADES, PAGEANTS, SPORTS,
AND MUSIC

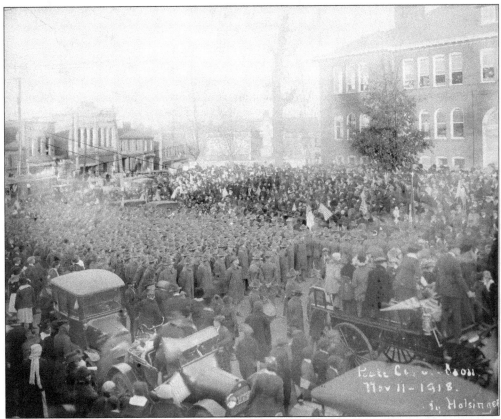

A crowd of thousands gathered in front of Midway School on November 11, 1918, to celebrate the end of World War I. (Courtesy of Holsinger Collection [MSS 9862], Special Collections, University of Virginia Library.)

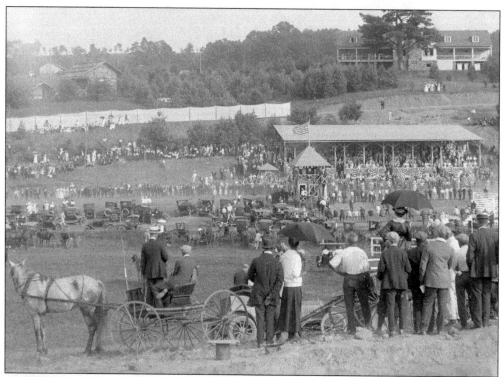

Established in 1900, the Albemarle Horse Show Association held an annual exposition in Fry's Spring. In 1916, the association purchased a 20-acre tract in Meadow Creek and constructed a racetrack, stables, and judge's stand. The exhibition pictured here was held in August. After the event, severe rainstorms washed away a concrete culvert, and the site was abandoned. (Courtesy of Holsinger Collection [MSS 9862], Special Collections, University of Virginia Library.)

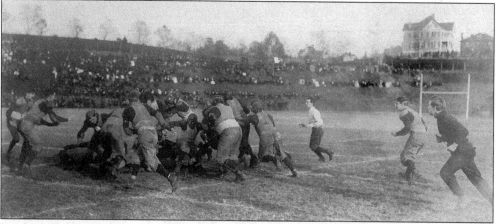

Lambeth Field opened in the 1890s and football games were played there for years before the colonnade and tiered seating were constructed. In this c. 1905 image, only one large house stands in the area that would become University Circle. Collegiate football nearly ended in 1909 with the death of a first-year UVa player during a game. President Alderman and UVa athletic director William Lambeth met with the presidents of other major universities that year and helped institute new rules, shaping the way college football is played today. (Courtesy of the University of Virginia Alumni Association.)

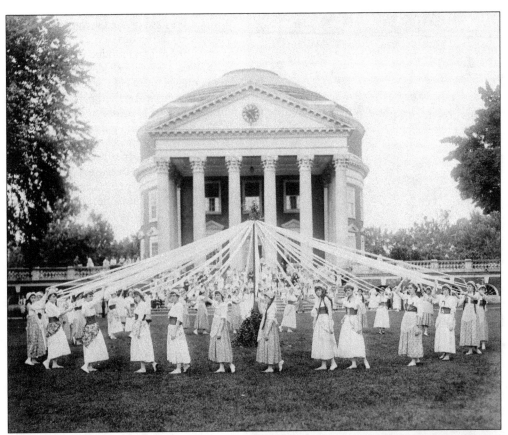

The grassy expanse of the Lawn offered a central gathering place for the pageants and celebrations popular at the University throughout the 19th and early 20th centuries. This image shows a maypole dance during a pageant in 1917. (Courtesy of Holsinger Collection [MSS 9862], Special Collections, University of Virginia Library.)

In 1928, Lady Astor, guest of honor at the UVa–South Carolina football game, posed with the rival team captains. The UVa captain, Bill Luke, is shown on the right. Lady Nancy Astor was the daughter of a wealthy tobacco farmer and grew up at Mirador in Albemarle County. In 1906, she married Waldorf Astor. In 1919, she became the first woman elected to the British Parliament and assumed her husband's former seat in the British House of Commons. (Courtesy of Visual History Collection [RG-30/1/10.011], Special Collections, University of Virginia Library.)

William Bernard of the University Theatrical Club poses in his costume for the 1919 musical production, *O Susie Behave*. The musical, produced and managed entirely by students, was a departure from standard plays and musicals in that it consisted of a series of vignettes of contemporary New York productions. *O Susie Behave* was such a resounding success that it went on the road, performing in nearly every town in Virginia. (Courtesy of Holsinger Collection [MSS 9862], Special Collections, University of Virginia Library.)

Three students don costumes to boost support for the UVa football team at a game at Lambeth Field, around 1915. (Courtesy of Holsinger Collection [MSS 9862], Special Collections, University of Virginia Library.)

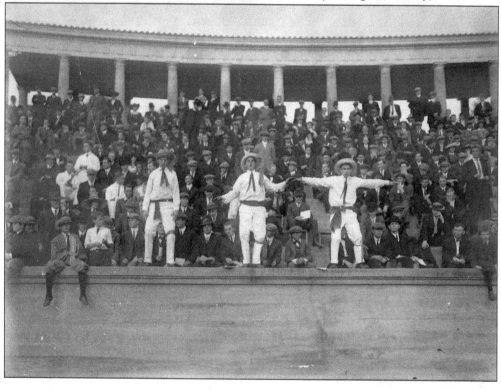

At a 1913 Fourth of July celebration, several students and women reenact the scene of the signing of the Declaration of Independence in front of Fayerweather Hall. (Courtesy of Holsinger Collection [MSS 9862], Special Collections, University of Virginia Library.)

On July 4, 1936, at the height of the Depression, Franklin Delano Roosevelt addressed a large crowd at Monticello. In his closing remarks, he stated, "The world has never had as much human ability as it needs; and a modern democracy in particular needs, above all things, the continuance of the spirit of youth. Our problems of 1936 call as greatly for the continuation of imagination and energy and capacity for responsibility as did the age of Thomas Jefferson and his fellows." (Courtesy of the Library of Virginia.)

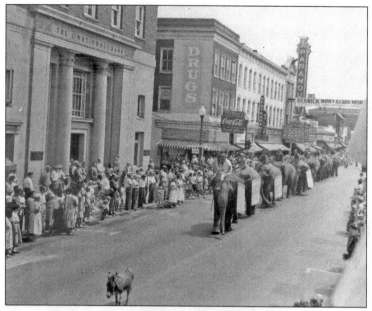

In 1940, a circus parade marched westward past the 200 block of East Main Street. The elephants carried advertisements for local businesses, such as Leggett's, and *Gone With the Wind* played at the Paramount. The two buildings west (left) of the Paramount Theater burned in 1973. (Courtesy of the Albemarle Charlottesville Historical Society, Russell "Rip" Payne Collection.)

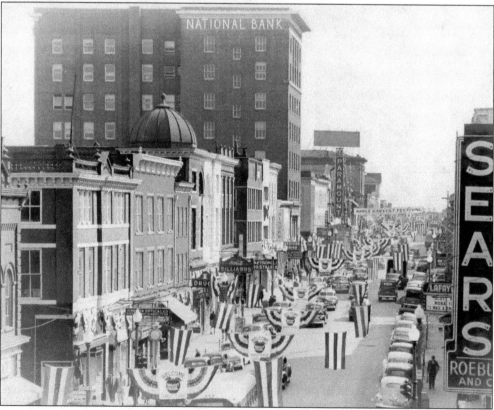

Beginning in 1950 as a fall festival celebrating the local apple industry, the Apple Harvest Festival continued until 1957 when it was moved to the spring and was renamed the Dogwood Festival. This image shows the Apple Harvest Festival Parade moving down East Main Street in 1953. The Lafayette Theater marquee is visible in the lower right. (Courtesy of Ed Roseberry.)

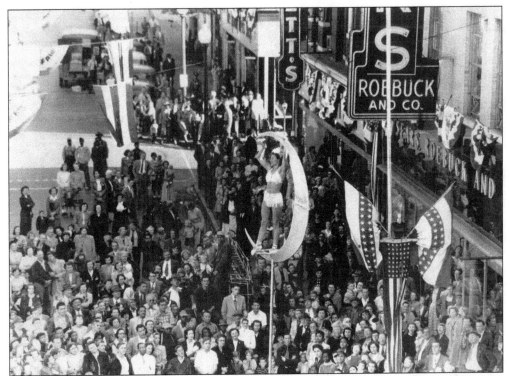

A large crowd gathered to watch a female trapeze artist during the 1951 Apple Harvest Festival. (Courtesy of Ed Roseberry.)

The Fry's Spring Beach Club was a popular dance pavilion and entertainment venue from the 1920s to the 1960s. This cabaret show at the Beach Club was sponsored by the University League in 1966. (Courtesy of Ed Roseberry.)

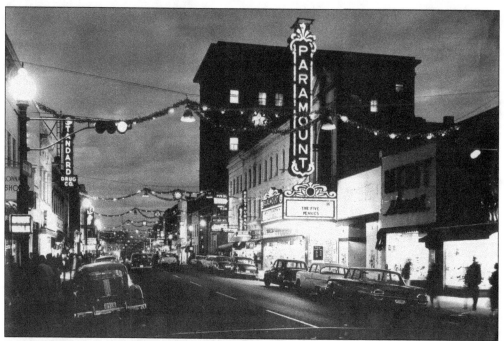

East Main Street was decorated with lights and garland for the 1959 holiday season. (Courtesy of Ed Roseberry.)

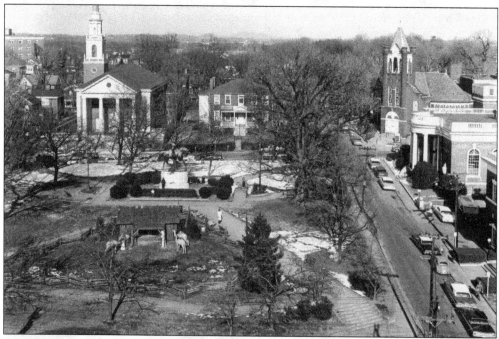

A life-size nativity scene was erected in Lee Park each Christmas from the 1940s until 1984, when City Council voted against placing the nativity scene on city property out of concern that it violated the separation of church and state. Note the First Baptist Church in the background on the right; it burned in 1977. The McIntire Building, now the Albemarle Charlottesville Historical Society, is located in front of the church. (Courtesy of Ed Roseberry.)

The 1956 film *Giant*, directed by George Stevens and starring Elizabeth Taylor, Rock Hudson, and James Dean, was filmed in part at Belmont Farm near Keswick in Albemarle County. The Keswick railroad station, renamed "Ardmore" for the movie, is shown at the far right. Rock and Elizabeth, her hair in curlers, are shown in the foreground. (Courtesy of Ed Roseberry.)

The cast and crew spent 10 days filming in Albemarle County. The film won an Academy Award for Best Director and was nominated for nine other Academy Awards, including Best Actor for both Rock Hudson and James Dean; Dean died shortly before the release of the film. Hudson is shown in the center right, with Elizabeth Taylor to his right. Rod Taylor is seated at the far end of the table on the left. (Courtesy of Ed Roseberry.)

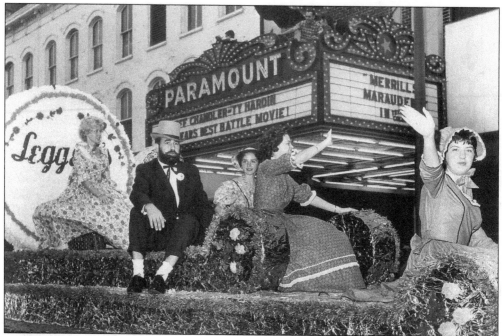

In 1962, Charlottesville celebrated its 200th anniversary with a series of summer events and parades. Members of the Order of Cavaliers were encouraged to grow beards, and if they refused, they were collected and thrown into a mock jail during one of the celebration events. The image above shows men and women in costume for a parade in July. The image below shows a group of dancers in front of the Monticello Hotel on Court Square. (Both, courtesy of Ed Roseberry.)

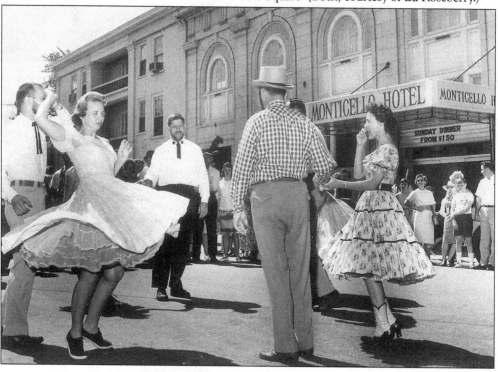

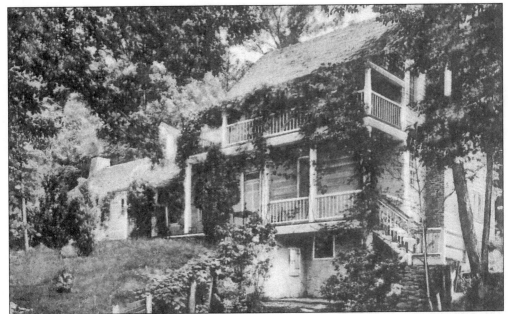

Michie Tavern, established by John Michie in northern Albemarle County in the 1780s, provided lodging and food for travelers. The tavern remained in the family until 1910, when it was eventually purchased by Josephine Henderson to showcase her antiques collection. Henderson moved the tavern to its present location on Brown's Mountain in 1927. Today, it houses a restaurant and museum. (Courtesy of Preston Coiner.)

Joanne Peregoy, daughter of a previous owner of Michie Tavern, holds a commemorative plate celebrating the 1976 Bicentennial. (Courtesy of Ed Roseberry.)

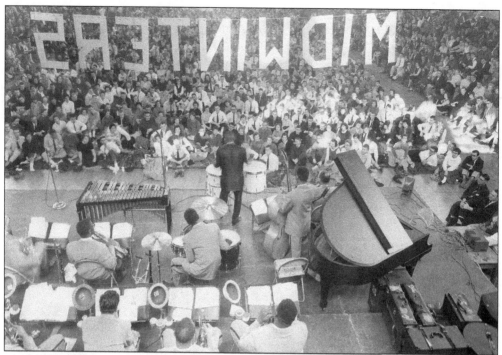

Memorial Gymnasium was the premier venue for musical acts at the University until the 1980s, when expanding concert crowds required the acts to move to University Hall. The Midwinters celebration was one of four annual events sponsored by the University and usually involved a musical act, such as the one shown in this image around 1960. (Courtesy of Ed Roseberry.)

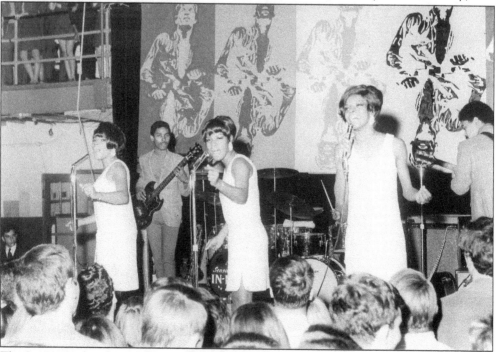

The Supremes played to a full house at Mem Gym in 1966. (Courtesy of Ed Roseberry.)

The great jazz musician Duke Ellington played at Mem Gym in 1961. At that time, segregation was still embedded in Charlottesville's cultural and political life. Ellington stayed where many visiting African Americans stayed—the Carver Inn on Preston Avenue. (Courtesy of Ed Roseberry.)

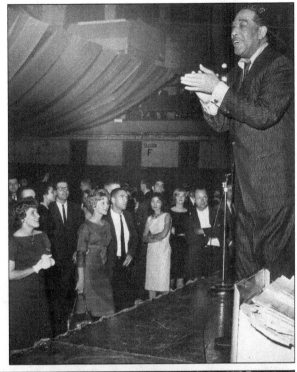

Fats Domino, the influential rock-and-roll pianist and singer-songwriter, played at Mem Gym in 1959 and celebrated afterward with students. Frank Kessler, who later became a prominent local developer, stands next to Fats in a striped suit and bow tie. (Courtesy of Ed Roseberry.)

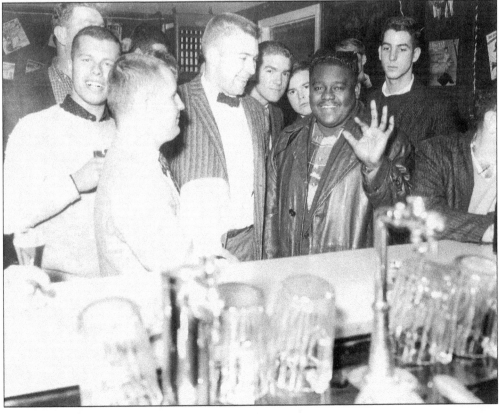

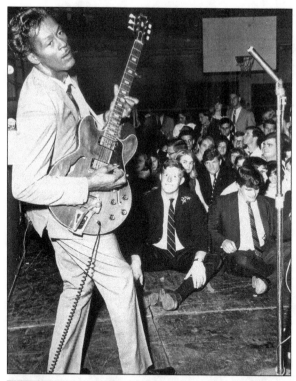

Chuck Berry, a pioneer of rock-and-roll music with hits such as "Maybellene" and "Johnny B. Goode," played at Mem Gym in 1965. (Courtesy of Ed Roseberry.)

University fraternity students construct a literal interpretation of a beer garden in front of the Beta Bridge around 1960. The Beta Bridge, located on Rugby Avenue, was named for the Beta Theta Pi fraternity, now the Delta Upsilon fraternity, whose house was built next to the bridge in 1927. (Courtesy of Ed Roseberry.)

On March 20, 1965, during the
Vietnam War, former president
Harry S. Truman addressed a
crowd in Mem Gym. On that
same night, folk singer and activist
Joan Baez played across the street
at Alumni Hall for the annual
Beaux-Arts Ball sponsored by the
School of Architecture. (Both,
courtesy of Ed Roseberry.)

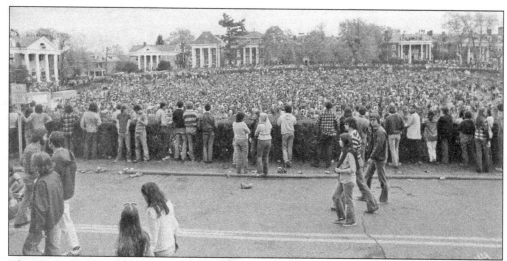

The Easters tradition started as a way to celebrate the break from studies around the Easter holidays, possibly as early as the 1890s. Festivities initially consisted of chaperoned dances. The event grew in the 1950s, and by the 1970s, thousands of people from all over the East Coast descended upon Charlottesville to celebrate Easters. What became known as the "Best Party in the Country" took place in Mad Bowl, fostered by copious amounts of alcohol. In response to a growing concern for student safety, University officials tried to curtail the event by relocating it to the smaller Lambeth Field in 1977. When this proved unsuccessful, the University officially canceled Easters in 1982. This image and the one below were taken in 1976 at the last Easters party held in Mad Bowl. (Courtesy of Jim Carpenter.)

The mud slide was a high point of Easters festivities. (Courtesy of Jim Carpenter.)

At the beginning of every UVa
football game, Cavman, a man
dressed up in full Cavalier
regalia including a sword and
orange and blue cape, charges on
horseback into Scott Stadium.
This Cavman poses for the camera
before charging the field in 1965.
(Courtesy of Ed Roseberry.)

In 1976, the Cavaliers
won their first and only
ACC championship. Marc
Iavaroni is hoisted in the air
to cut the net from the hoop
in celebration. (Courtesy
of the *Daily Progress*.)

Civil rights activist Rosa Parks, referred to as "the mother of the freedom movement" by the US Congress, spoke at the University in 1990. (Courtesy of Visual History Collection [RG-30/1/10.011], Special Collections, University of Virginia Library, photograph by Angelita Plemmer.)

On July 10, 1976, Queen Elizabeth II visited Monticello and the University to celebrate the American Bicentennial. James Bear, former curator of Monticello, escorts the Queen from the house. Gov. Mills Godwin follows close behind. The Queen's husband, Prince Philip, Duke of Edinburgh, is shown on the far right. (Courtesy of Ed Roseberry.)

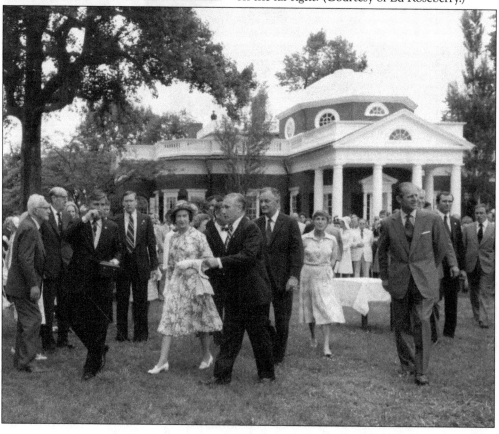

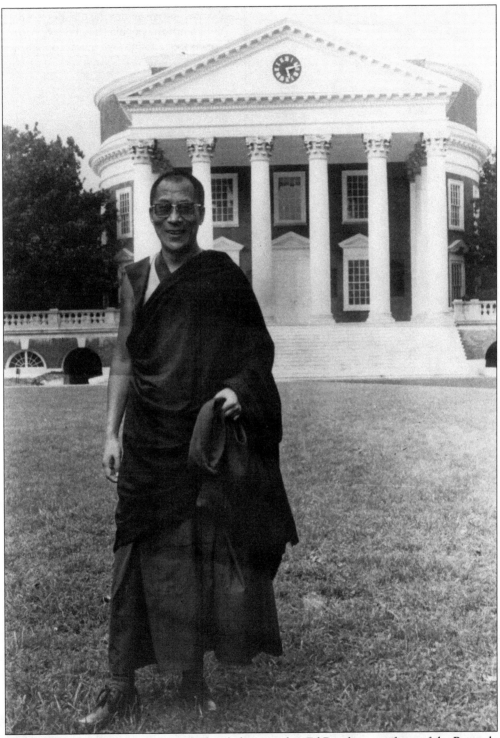

His Holiness the Dalai Lama poses for local photographer Ed Roseberry in front of the Rotunda on his visit in September 1979. (Courtesy of Visual History Collection [RG-30/1/10.011], Special Collections, University of Virginia Library, photograph by Ed Roseberry.)

A crowd gathers under the Charlottesville Pavilion for the popular free Fridays After Five concert. (Courtesy of Jack Looney.)

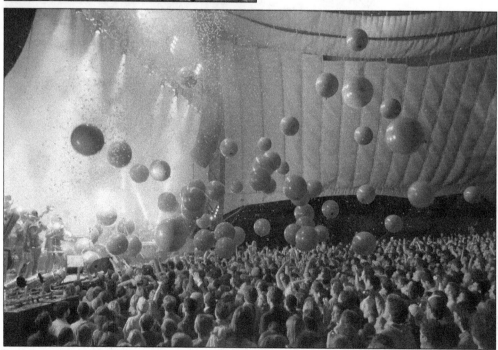

Balloons and confetti fill the air at the Pavilion during a Flaming Lips concert in July 2010. (Courtesy of Jack Looney.)

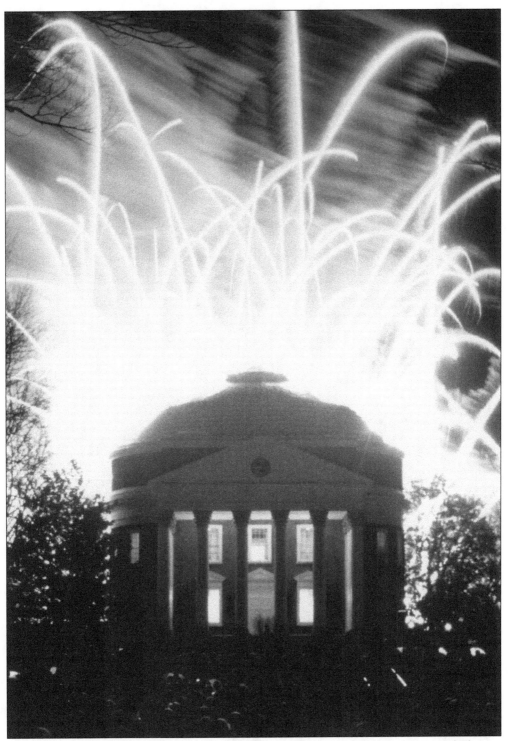

Fireworks silhouette the Rotunda and its dome in celebration of the anniversary of Thomas Jefferson's 250th birthday. (Courtesy of Visual History Collection [RG-30/1/10.011], Special Collections, University of Virginia Library, photograph by Laura Pretorius.)

127

Visit us at
arcadiapublishing.com